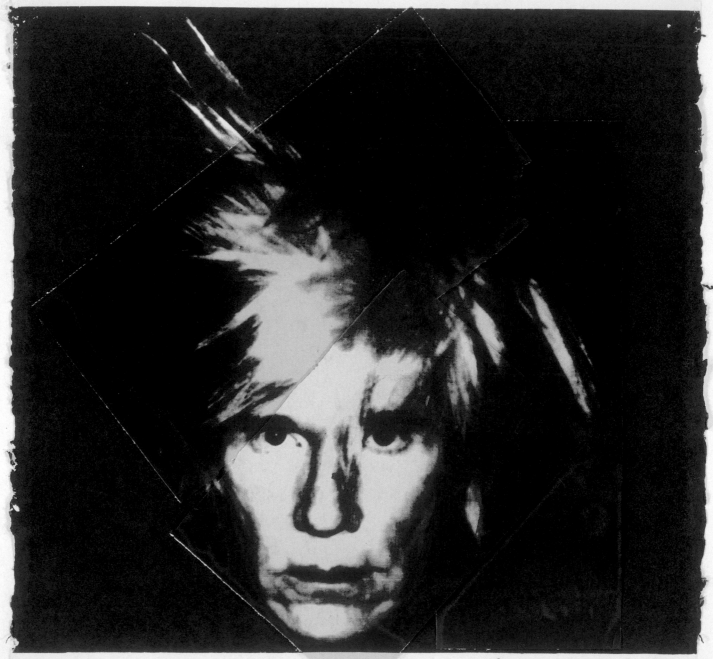

Andy Warhol 86

Keith Hartley

Warhol

A Celebration of Life ... and Death

National Galleries of Scotland
Edinburgh 2007

Published by the Trustees of the National Galleries of Scotland to accompany the exhibition *Andy Warhol: A Celebration of Life ... and Death* held at the National Gallery Complex, Edinburgh from 4 August until 7 October 2007.

ISBN 978 1 903278 99 4

Designed and typeset in Swift by Dalrymple
Printed in Belgium on Perigord Matt 150gsm by Die Keure

Front cover: detail from *Liza Minnelli* 1979 [**59**]

Frontispiece: *Self-portrait* 1986, screenprint and coloured graphic art paper collage on hand-made paper 80 × 61cm, Scottish National Gallery of Modern Art, Edinburgh, on loan from a Private Collection

Back Cover: *Skull* 1976 [**77**]

The proceeds from the sale of this book go towards supporting the National Galleries of Scotland.

www. nationalgalleries.org

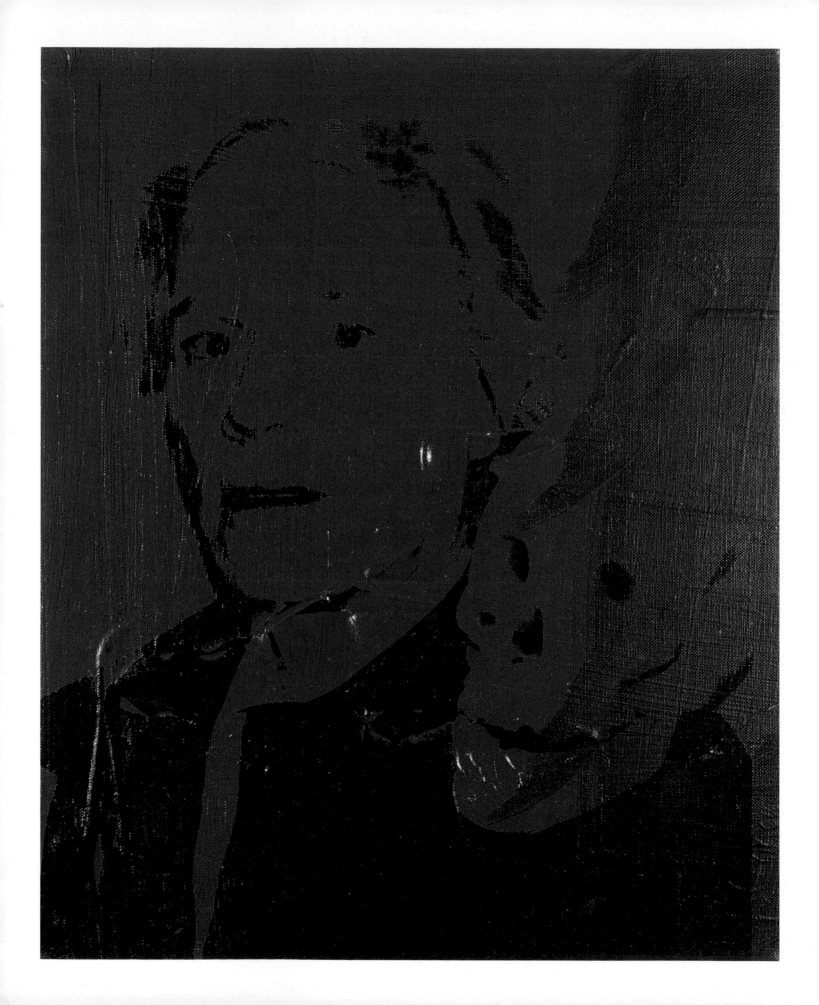

In 2005 the National Galleries of Scotland, in collaboration with the Sprengel Museum, Hanover and the St Gallen Museum, put on *Andy Warhol Self-Portraits*, the first exhibition devoted to Warhol mounted in Scotland. It was sharply focused and gave a unique insight into Warhol's media-savvy manipulation of his own image. However, the exhibition looked at only one aspect of Warhol's multifarious activities as an artist and artistic entrepreneur. What was needed was a broader look at the artist, at a variety of his series of paintings, at a fuller spectrum of the mediums he used – not only paintings, but sculptures, drawings, collages, prints, films, photographs, installations, wallpaper, and ephemera. This we hope to do with the present exhibition, *Andy Warhol: A Celebration of Life ... and Death*.

Death has long been acknowledged as a key theme in Warhol's work, from his early paintings of the recently deceased Marilyn Monroe in 1962 to *The Last Supper*

Foreword

paintings made in 1986 and shown in Milan only weeks before his untimely death in 1987.

Warhol was fascinated by death in its various guises: the high profile death of a star (Marilyn Monroe); the public event of a political assassination (President John F. Kennedy) and its effect on the widow (Jackie Kennedy); the gruesome death of car crashes, suicides and legal executions in his 'Death and Disaster' series; and death as a universal symbol in his 'Skull' series. Warhol was equally (and eagerly) attached to and fascinated by life – and, in particular, by modern life. His famous *Marilyn Diptych* [21] is as much a tribute to her as a living icon of the screen as to her death by suicide. In similar fashion, the paintings of the skulls show that life and death are inextricably united. The cast shadow of the skull takes on the shape of a baby's profile. Moreover, in celebrating contemporary American consumer culture in the form of Campbell's soup cans, Coca-Cola bottles and Brillo boxes, Warhol was celebrating life as it then was for millions of Americans and, increasingly, for people around the world. His celebrity portraits hold up a mirror to an important aspect of modern life, even if we dislike its superficiality. Life and death are traditional themes in the history of art but Warhol gave them an extra and more immediate claim by using photography as the basis of most

of his art. Photographs capture life as it is – or as it seems to be – but they are also key signifiers of the passing of time and ultimately, therefore, of death itself.

Andy Warhol: A Celebration of Life ... and Death is the first of two exhibitions devoted to major postwar artists. The second, in the autumn of 2008, will be devoted to the German artist, Joseph Beuys. Both exhibitions are being generously sponsored by Bank of Scotland under the overall title of Bank of Scotland TotalArt. TotalArt conveys the encompassing nature of both Warhol's and Beuys's artistic ambitions, their wish to look at life and society in their broadest parameters. Both artists used a wide range of mediums and, in their very different ways, engaged in social interaction as part of their art. They both had and continue to have an enormous impact on the way art has developed over the past thirty or forty years. We would like to take this opportunity of thanking most warmly Bank of Scotland, and, in particular, its Chairman, Lord Stevenson, for their wholehearted support for this ambitious project and for their determination that as wide a public as possible will benefit from both exhibitions and their related education programmes.

No exhibition is possible without institutions and individuals who are prepared to lend their works to it. This is particularly true of this exhibition, since the burden has fallen heavily on relatively few. We are conscious of the debt we owe The Andy Warhol Museum in Pittsburgh, which is lending over one hundred works to the show. Its Director, Tom Sokolowski, has given his unstinting backing to the exhibition and has been full of generous and helpful advice in its shaping. His staff, especially Greg Burchard, Geralyn Huxley, Heather Kowalski, Jesse Kowalski, and Matt Wrbican have devoted much time and effort to supplying photographic material, showing works to the exhibition's curators, and answering numerous questions.

We are also hugely indebted to Anthony d'Offay for lending us a large group of works from his collection and for his important collaboration with Keith Hartley, Acting Director of the Scottish National Gallery of Modern Art, who has curated the show. His knowledge, contacts and insight into Warhol's work have been invaluable. Grateful thanks must go to his colleagues, Marie-Louise Laband and James Elliott, for the huge amount of work that they have put into this exhibition.

We would also like to thank Sir Nicholas Serota, Director of Tate, for agreeing to lend its much-requested, iconic

1 | SELF-PORTRAIT WITH SKULL 1978

Acrylic and silkscreen ink on canvas
40.6 × 33cm
Scottish National Gallery of Modern Art, Edinburgh, on loan from a Private Collection

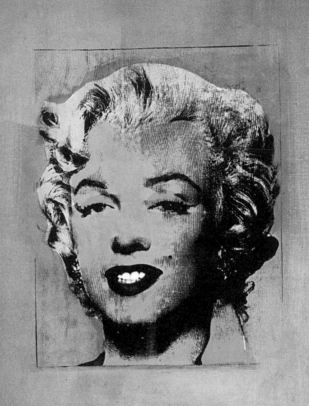

The screening we had of ✶✶✶✶ in December [1979] at the Cinémathèque ... brought back all our early days of shooting movies just for the fun and beauty of getting down what was happening with all the people we knew ...

We sat there in the dark at the Cinémathèque watching reel after reel of footage we'd shot all that year, every place we'd been – San Francisco, Sausalito, Los Angeles, Philadelphia, Boston, East Hampton and all over New York, of friends like Ondine, Edie, Ingrid, Nico, Tiger, Ultra, Taylor, Andrea, Patrick, Tally Brown, Eric, Susan Bottomly, Ivy Nicholson, Brigit, Gerard, Rene, Allen Midgette, Orion, Katrina, Viva, Joe Dallesandro, Tom Baker, David Croland, the Bananas. Seeing it all together that night somehow made it seem more real to me (I mean, more unreal, which was actually more real) than it had when it was happening – to see Edie and Ondine huddled together in a windy deserted beach on a grey day, with only the sound of the camera, and their voices getting blown away over the sand dunes while they tried to light their cigarettes. Some people

A Celebration of Life ... and Death

stayed throughout the entire screening, some drifted in and out, some were asleep out in the lobby, some were asleep in their seats, and some were like me, they couldn't take their eyes off the screen for a single second. The strange thing was, this was the first time I was seeing it all myself – we'd just come straight to the theatre with all the reels. I knew we'd never screen it in this long way again, so it was like life, our lives, flashing in front of us – it would just go by once and we'd never see it again.[1]

In this highly evocative, indeed moving, passage from his memoirs of the 1960s, POPism: *The Warhol '60s*, Andy Warhol (assisted by the literate Pat Hackett, who edited Warhol's diaries) goes to the very heart not only of his film-making, but of his art in general. Art was for him a way of capturing life of the moment, just as it was lived, with as little editing and authorial intervention as possible. The camera, the film camera, the tape recorder were Warhol's preferred means of doing this, because they were machines, with no minds of their own, no aesthetic or moral preconceptions. They simply recorded what they were set to record. The rub, of course, lay in the fact that these machines had to be set up by somebody, placed in front of a particular person or scene, at a particular angle, with a particular type of lighting. This all involved choice. And if 'found' photographic images were

involved as they were with most of Warhol's paintings and prints of the 1960s, one photograph of one person or object had to be selected rather than another. Warhol, of course, was deeply aware of this, as his often quoted remark, 'I want to be a machine', by implication, makes clear.[2]

Warhol's radical realism – for that, ultimately, is what much of his art was about – did not extend to a total abandonment of artistic choice. He knew exactly what interested him, and what would capture the spirit of the time. But, he did care that the images, which he created, whether still, in the form of paintings, or moving, in the form of films, looked mechanically produced and art-less. He wanted to give the impression that life – modern life and all that that entailed – was being captured directly, without passing through the distorting prism of an artistic temperament. To this end he used the technique of screenprinting to transfer photographic images onto canvas to create his

paintings and prints. This is why, in many of his early films and screen tests, he allowed the camera, after being trained on the subject, to run automatically, with no pans, zooms, tilts or other interventions until the film ran out. Composition in many of his works would be limited to repeating the same image over and over again. If a screen got clogged with ink so that the image became less distinct as the printed image progressed, Warhol accepted this as part of the mechanical process. Life was like that and likeness to life – real life – was one of Warhol's central concerns.

What exactly was the life that Warhol was trying to capture in his art and films? How personal was it to him and to his tastes? His perspective on life was, of course, heavily informed by his personal tastes – for Hollywood glamour and film stars, for example – and by his career as a commercial artist in New York in the 1950s, when he drew illustrations for fashion articles (shoes, in particular) and other commercial products [3]. In many respects, this gave him a highly representative, even if privileged, position as an American growing up and maturing in what was the world's most successful, capitalist economy. Hollywood and Madison Avenue were two of the driving forces behind America's rapidly growing prosperity. And the same forces were being felt elsewhere in the world, in Europe, in

2 | GOLD MARILYN MONROE 1962

Synthetic polymer paint, silkscreened, and oil on canvas
211.4 × 144.7cm
Museum of Modern Art (MoMA), New York. Gift of Philip Johnson.

particular. At the same time, however, the drawings that Warhol did as proposed illustrations for books show his interest in the darker side of American life. The drawings of a drug-injecting young man that he made for *The Nation's Nightmare* [4] looks forward to some of the films that Warhol would make in the mid-1960s.

It is, therefore, not surprising that, when Warhol turned to (so-called) fine art, to paintings, prints and sculptures in the early 1960s, the subjects he chose were overwhelmingly of Hollywood and media stars and of common consumer products – Campbell's soup cans, Brillo boxes, and Coca-Cola bottles. These were all quintessentially American and emblematic of early postwar American glamour and prosperity. Warhol was an unashamedly patriotic American, typical of the son of an immigrant family, someone who came from a poor background but was able through his own talents to rise to the top of his profession. By the late 1950s

just think, you can drink Coke, too. A Coke is a Coke and no amount of money can get you a better Coke than the one the bum on the corner is drinking. All the Cokes are the same and all the Cokes are good. Liz Taylor knows it, the President knows it, the bum knows it, and you know it.[3]

In similar fashion, Hollywood films and stars reflected a common, popular culture, not a stratified, class-bound culture.

The techniques that he borrowed from the world of advertising were the use of clearly readable, iconic images, the use of bright, optimistic colours, and the constant repetition of the same image. In addition, Warhol liked to work in series, and when he felt that he had hit upon a successful subject and image, he would make multiple paintings of it in different colour combinations and on differently sized canvases. When the same image was repeated on the same canvas, it looked like a block of

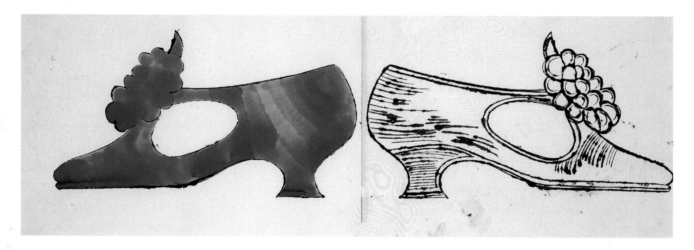

Warhol was perhaps the top-earning commercial illustrator in New York. For Warhol the American dream had come true. This gave him an especially keen insight into how that dream functioned, and how it was manipulated by Hollywood and Madison Avenue to sell films and commercial products. Warhol would copy these techniques, not to expose an exploitative money machine – Warhol was no social revolutionary – but to celebrate what he saw as the icons of a well-functioning, deeply democratic and egalitarian society. He noted that products like Campbell's soup and Coca-Cola were consumed by *all* Americans no matter how poor or rich they were and wrote:

What's great about this country is that America started the tradition where the richest consumers buy essentially the same things as the poorest. You can be watching TV and see Coca-Cola and you know that the President drinks Coke, Liz Taylor drinks Coke, and

postage stamps, a wall of posters, or, more significantly, successive exposures on a reel of film. Repetition reached its ultimate formulation in his work *Brillo Boxes* [33], where wooden boxes were painted to look like real Brillo boxes and were produced in large numbers: to all intents and purposes they are identical. This represented a fundamental shift away from the concept of the unique work of art and, in particular, from the abstract expressionist notion that a work of art was the expression of the artist's psyche, a record of the existential struggle between the artist's self and the world. Warhol preferred the altogether cooler, more detached notion of art adopted by the ultra urbane, French / American Dadaist, Marcel Duchamp, and, in particular, his use of the readymade or found object that he declared to be a work of art. The thirty-two paintings of Campbell's soup cans, each a different type of soup, that Warhol made for the

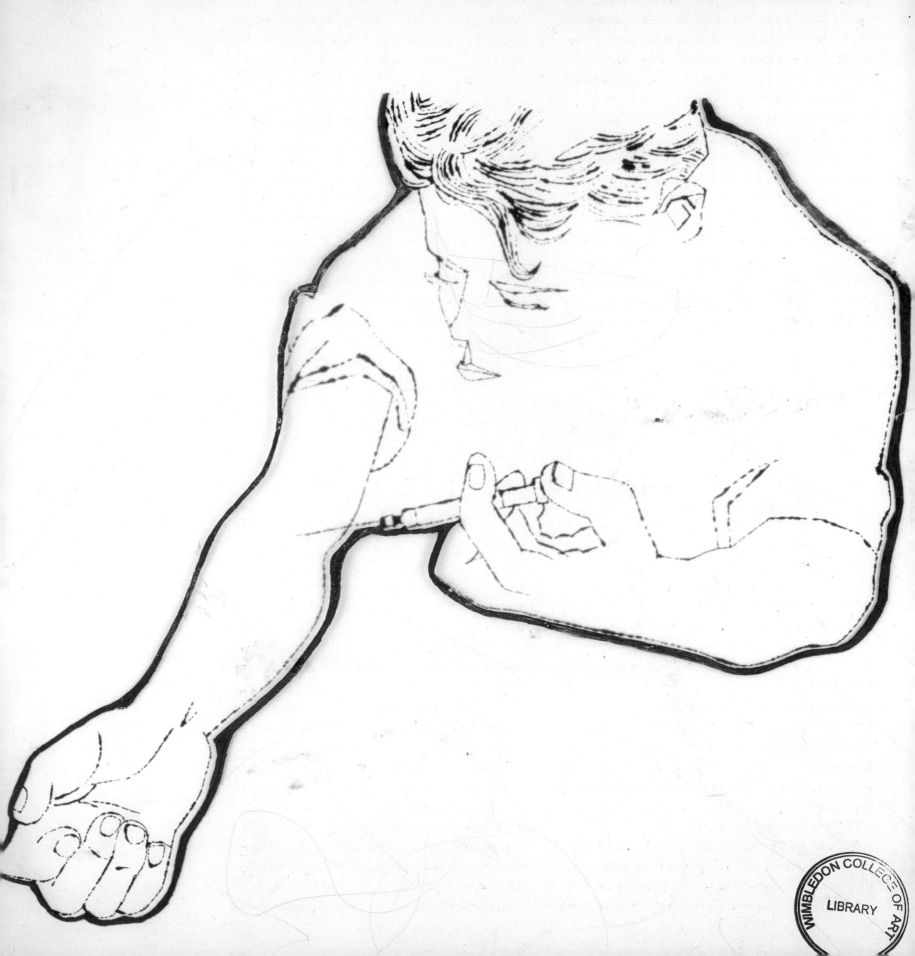

Ferus Gallery in Los Angeles, are not only iconic in their treatment, they also take on the appearance of readymades [5]. Warhol liked the intellectual rigour and clarity of Duchamp's appropriation of the real world, but unlike Duchamp's readymades – his upturned urinal, his snow shovel, his bicycle wheel set on a stool – which are enigmatic and seemingly resonant with recondite meanings, Warhol's *Brillo Boxes* are no more than they purport to be, painted replicas of an iconic brand product, or at least its packaging. The viewer knows that the boxes are not the real thing, that they do not contain real scouring pads, but he or she relishes the in-joke and, more importantly, finds satisfaction in this triumph of the banal and the ordinary.

According to Susan Sontag, this enjoyment of vulgarity, in the sense of what is common, even coarse, is one of the characteristics associated with the camp sensibility.[4] She compares the dandy in his (usually *his*) turn-of-the-century refined taste with the 'connoisseur of camp'. The latter: ' ... has found more ingenious pleasures. Not in Latin poetry and rare wines and velvet jackets, but in the coarsest, common-est pleasures in the arts of the masses. Mere use does not define the object of his pleasure, since he learns to possess

them in a rare way. Camp-dandyism in the age of mass culture – makes no distinction between the unique object and the mass-produced object. Camp taste transcends the nausea of the replica.'[5]

Sontag's essay *Notes on 'Camp'* was published in *The Partisan Review* in 1964, when Pop Art, and Warhol's in particular, was enjoying great success. She sensed that there were connections between camp, as she defined it, and Pop Art, but in the end she saw a crucial difference: ' ... one may compare Camp with much of Pop Art, which – when it is not just Camp – embodies an attitude that is related, but still very different. Pop Art is more flat and more dry, more serious, more detached, ultimately nihilistic.'[6]

Warhol's depiction of consumer products, film stars and celebrities is certainly dry, serious and detached. Following advice from his friend Emile de Antonio, Warhol had deliberately eschewed a warm, painterly style for a cool, hard-edged treatment of objects. In his book POP*ism* he describes how in about 1960 he showed De (as he called him) two paintings: 'One of them was a Coke bottle with Abstract Expressionist hash marks halfway up the side. The second one was just a stark, outlined Coke bottle in black and

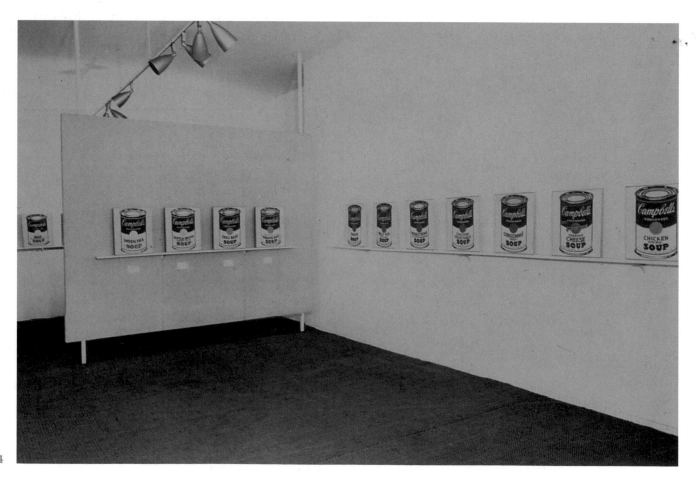

5 | ANDY WARHOL'S CAMPBELL'S SOUP CANS AT THE FERUS GALLERY, LOS ANGELES 1962

Black and white photograph
The Andy Warhol Museum, Pittsburgh, Founding Collection, Contribution The Andy Warhol Foundation for the Visual Arts, Inc.

white. I didn't say a thing to De. I didn't have to – he knew what I wanted to know. "Well, look Andy," he said after staring at them for a couple of minutes. "One of these is a piece of shit, simply a little bit of everything. The other is remarkable – it's our society, it's who we are, it's absolutely beautiful and naked, and you ought to destroy the first one and show the other."' Warhol goes on: 'That afternoon was an important one for me ... I still had the two styles I was working in – the more lyrical painting with gestures and drips, and the hard style without the gestures. I liked to show both to people to goad them into commenting on the differences, because I still wasn't sure if you could completely remove all the hand gesture from art and become noncommittal, anonymous. I knew that I definitely wanted to take away the commentary of the gestures ... The works I was most satisfied with were the cold "no comment" paintings'.[7]

The fact that Warhol preferred the 'no comment' paintings, what Sontag would have called 'more dry, more serious, more detached', does not mean that they were 'ultimately nihilistic'. Indeed, one could argue that by leaving his paintings and sculptures of mass-media objects and stars unadorned and 'naked', Warhol was showing a greater emotional commitment to them. They did not need his gestural endorsement to assert their importance in our culture. In similar fashion, Warhol adopted a detached, 'no comment' style in his dealing with the press and the outside world in general. (Among his close circle of friends Warhol was chatty and articulate.) This all reinforced the impression that he was holding up a mirror to modern life and not interpreting it. This neatly ignores the central fact that it was Warhol who *chose* to mirror certain things and people, rather than others.

The objects he chose to depict came from the commercial world of brand-named, consumer products, rather than generic items that might be found in a traditional still life of, say, meat, fish, eggs, fruit and vegetables. These only find their way into Warhol's paintings and sculptures in the painted lettering showing what type of soup 'is' in the Campbell's cans, or what type of fruit 'is' in the Del Monte tins. This is the modern consumer world, the world of supermarket shelves rather than the world of markets and greengrocers' shops.

Most of the people Warhol depicted are specific, named individuals and, at least in the 1960s, nearly all film stars or celebrities – most famously, Marilyn Monroe [21], Elizabeth Taylor [20], Elvis Presley [22], and Jackie Kennedy [24]. He chose them not merely because of their fame and immediate recognisability, but also, significantly, because they were all touched in some way by death. He started making paintings of Marilyn Monroe shortly after she committed suicide in August 1962. One of the earliest and most iconic paintings that Warhol did of Marilyn is the so-called *Gold Marilyn* [2], in which her face is isolated in the middle of a large, gold-painted canvas. It is, in fact, very like a religious icon, the sort of paintings that are displayed in Orthodox Churches in Russia and Eastern Europe. In an interview in 1963 he said of his paintings of Elizabeth Taylor: 'I started those a long time ago, when she was so sick and everybody thought she was going to die.'[8] The image Warhol chose of Elvis Presley is of him aiming a gun. Jackie Kennedy was painted after her husband, President John F. Kennedy, had been assassinated in Dallas on 22 November 1963. He used press photos of her before and after the assassination, and during the funeral.

The fact that death appears as a subtext in these painting and as an outright subject in many more works has often been commented upon. Writers and critics have referred to Warhol's obsession with death, pointing out that after his father died and had been laid out in the family sitting-room, the fourteen-year-old Andy refused to look at his dead body. Two years later his mother had to be operated on for cancer. To what extent Warhol feared and was obsessed with death is a moot point. He was certainly obsessed with his health and looks, and visited doctors frequently to try and improve both. But he actually ascribed the idea of choosing death as a subject for his paintings to his friend, Henry Geldzahler, curator of modern and contemporary art at the Metropolitan Museum of Art in New York. He wrote: 'It was Henry who gave me the idea to start the Death and Disaster series. We were having lunch one day in the summer at Serendipity on East 60th Street and he laid the *Daily News* out on the table. The headline was "129 DIE IN JET". And that's what started me in the death series – the Car Crashes, the Disasters, the Electric Chairs ..."[9] Interestingly, Victor Bockris in his biography of Warhol, quotes Henry Geldzahler as making a contrast between life and death as themes for paintings in Warhol's work. 'As early as 4 June 1962 Henry Geldzahler had suggested that Andy start looking at the other side of American culture. "That's enough affirmation of life," he had said. "What do you mean?" Andy had asked. "It's enough affirmation of soup and Coke bottles. Maybe everything isn't always so fabulous in America. It's time for

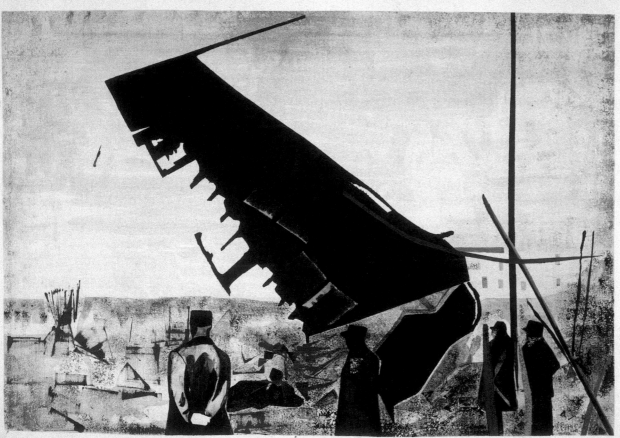

**6 | DIE IN JET
(PLANE CRASH)** 1962

Acrylic on canvas 254.5 × 182.5cm
Ludwig Museum, Cologne

7 | LAVENDER DISASTER
1963

Acrylic, silkscreen ink, and pencil
on linen 269.3 × 208.2cm
The Menil Collection, Houston

**8 | MOST WANTED MEN
NO.12, FRANK B** 1964

Silkscreen ink on linen
121.9 × 99.1cm
The Andy Warhol Museum,
Pittsburgh, Founding Collection,
Contribution The Andy Warhol
Foundation for the Visual
Arts, Inc.

some death. This is what's really happening."[10] The newspaper that Geldzahler showed Warhol was actually the *New York Mirror*, but Warhol was right to pinpoint the painting that he did, based on the front page photograph of the crashed jet, as the beginning of his 'Death and Disaster' series [6]. In November 1963, in an interview with G.R. Swenson, on being asked when he began the series, he replied: 'I guess it was the big plane crash picture, the front of a newspaper: 129 DIE. I was also painting the *Marilyns*. I realised that everything I was doing must have been about Death. It was Christmas or Labor Day – a holiday – and every time you turned on the radio they said something like, "4 million are going to die."'[11]

In a way, Warhol was doing no more than echoing (or rather mirroring) the media's obsession with death, particularly if it was violent and / or gruesome, and with disasters. This was the modern world. But once Warhol had realised how varied and compulsive looking at newspaper imagery was he included in the series paintings of car crashes, suicides, funerals, hospital scenes, electric chairs, race riots and poisonings. These disturbing and poignant images are silkscreened onto the canvases, usually in multiple form. The more the images are repeated across the canvas, the less easy it becomes to read them, with the result that our shock at finding out the grisly subject matter is delayed. The repetition also serves to empty out the meaning of the image. Death, even a violent death, becomes banal, an everyday occurrence in America. When colour is used, as in

Gangster Funeral [39] or *Lavender Disaster* [7], the shades are often somewhat acid or subdued, adding to the melancholy mood of the paintings. Warhol seems to have had the idea of showing these related paintings together in early 1963.[12] The exhibition took place at the Galerie Ileana Sonnabend, Paris in 1964. Some of the paintings, such as the suicides and car crashes, show particularly graphic images of people jumping from high-rise buildings or their mangled bodies hanging out of twisted cars. In others the imagery was more poignant and all the more affecting for being understated. Instead of someone being strapped into an electric chair, all Warhol shows in his electric chair paintings is an empty chair in an empty room, with a sign, saying 'SILENCE', on the wall behind. The implication is that death brings permanent silence.

The 'Death and Disaster' paintings have an uncompromising, merciless quality about them. It is with these works above all that Warhol's reputation as a cold and voyeuristic artist was established. They also set a pattern for subsequent series and working practices. Warhol would henceforth tend to swing between painting series whose ultimate theme was death to doing more life-affirming, even light-hearted themes. The year 1964 was perhaps when he moved most decisively and frequently between life and death themes: from *Brillo Boxes* to the 'Death and Disaster' series, from the most wanted men murals in the New York World's Fair, which used images of criminals wanted by the police [8], to his flowers series, seemingly straightforward, decorative,

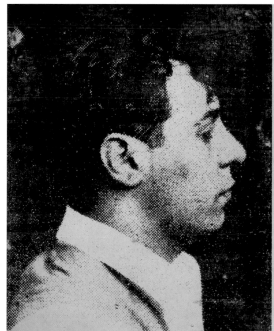

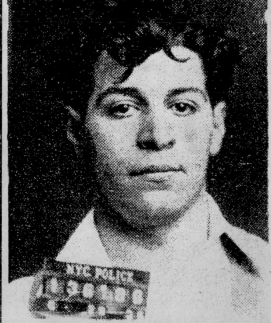

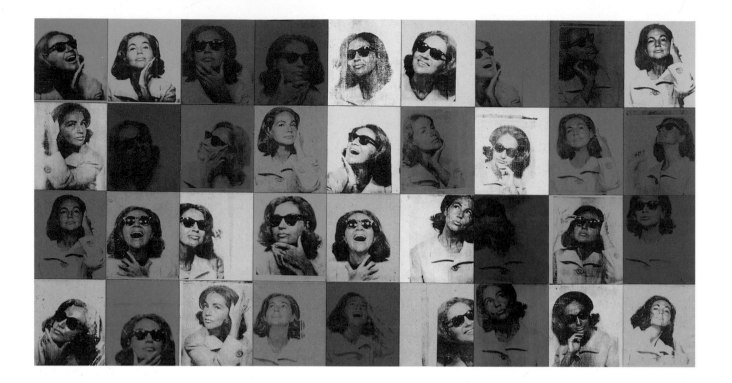

9 | ETHELL SCULL 36 TIMES 1963

Synthetic polymer paint silkscreened on canvas
202.5 × 363.8cm
Whitney Museum of American Art, New York;
Jointly owned by the Whitney Museum of American Art and The Metropolitan Museum of Art; Gift of Ethel Redner Scull

10 | INTERVIEW MAGAZINE WALL AT THE ANDY WARHOL MUSEUM

The Andy Warhol Museum, Pittsburgh, Founding Collection, Contribution The Andy Warhol Foundation for the Visual Arts, Inc.

and Matissian in their rich colours, but also carrying with them a hint of the graveside floral tribute or, at least, of the symbolism of death – flowers as a classic symbol of transience and decay.

Warhol's early New York studio on East 47th Street was called The Factory (although later studios were also known by the same name) and was famed for its groundbreaking parties. The habitués were would-be actors, drag queens, drug addicts, and musicians who became known as the Warhol superstars and who not only hung around as if at a permanent party but also starred in his films. Speaking in 2002, John Cale, musician, record producer and founding member of The Velvet Underground, said, 'It wasn't called the Factory for nothing. It was where the assembly line for screenprints happened. While one person was making a silkscreen, somebody else would be filming a screen test. Every day something new.'[13] From the mid-to late 1960s Warhol celebrated the lives, dreams and demons of these 'superstars' in his films. With little in the way of pre-established plots, let alone dialogue in the films, Warhol allowed these sad, funny, witty, eccentric, tormented, frustrated people, many of them *artistes manqués*, to play out their fantasies amongst and against each other. To all intents and purposes the *Screen Tests* were film portraits. The sitters – Factory regulars and beautiful and / or interesting visitors – were asked to sit in front of a screen looking directly at the camera without moving. Some of the sitters

could sit so still, barely blinking, that people who saw the films thought they were freeze-frames or photographs. Other sitters played up to the camera, assuming different poses and acting out different emotions. The set-up was very similar to the photo-booth photographs that Warhol had used for such paintings as *Ethel Scull 36 Times* [**9**]. He had posed Scull and other sitters in a photo booth and asked them to assume various positions and expressions. The composite paintings that resulted from these sessions recorded their changing faces across the canvas, thus introducing the element of time into the works. It was but one step from this procedure to the *Screen Tests*.

The films were as near as he could get to capturing life in the raw – with minimal editing, with as few movements of the camera as possible and, where possible, in real time. Warhol took this approach to its logical conclusion in films like *Sleep* (1963), in which the camera was focused on the naked body of the poet, John Giorno, sleeping for eight hours[14] and *Empire* (1964), where the Empire State Building was filmed from sunset to sunrise. Warhol acknowledged that for most people it was boring to watch films like these for their full duration and expected people to do other things at the same time and to come and go, as they felt inclined. The effect would be the same: to make people more aware of life about them, of things that they took for granted and ignored. Sleep, the act of sleeping, is a quite remarkable phenomenon, if considered not only as a

concept, but also as a perceived fact. The body goes into automatic mode, the conscious mind retreats inside and is only aware of its dreams, the personality disappears and brute fact takes over. In a similar way, except for tourists, the Empire State Building is usually no more than part of the backdrop of life in New York; most of the time it goes unnoticed. Seeing it in real time against the changing backdrop of the sky, we begin to perceive in it exactly the opposite way to how we perceive a sleeping body. Everything around it changes, the sun goes down, the moon comes up and goes down again and the sun rises. Day gives way to night, which in turn gives way to day again: the eternal circle of life. But, apart from lights going on and off, the Empire State Building remains the same, the same 'star' as Warhol called it.

Warhol's greatness lay in using film and photography to enable us to experience afresh what constituted life. Unlike modernist photographers who took precisionist close-ups of objects and people or looked at them from unusual angles and thereby gave us a new view of them, Warhol was not so concerned with visual detail, texture or form; his concern was more fact-based and experiential. In effect, he was saying: 'Look at this! Isn't it amazing that this exists, that this is part of our world.' His medium, for the most part, was visual,[15] but his aims were much broader – nothing less, in fact, than a sensitisation to all aspects of life, no matter how repugnant or controversial some of them might be, and a non-judgemental acceptance of them. Warhol saw this as fundamental to the Pop Art aesthetic. In his book POPism Warhol quotes approvingly Pope Paul VI's reply 'Tutti Buoni' (everything is good) when reporters asked him what he liked about New York. It was the Pop philosophy exactly.[16]

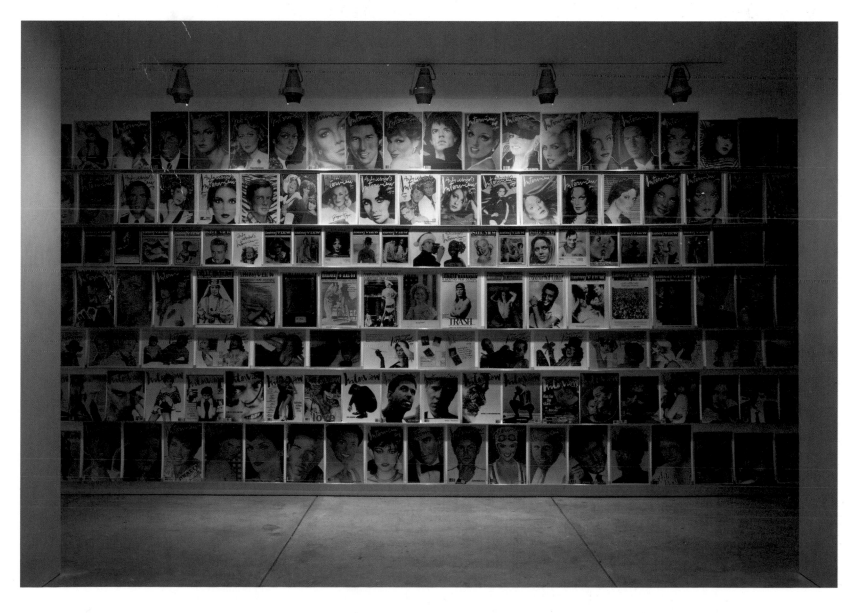

By the late 1960s Warhol had established the basic parameters of his art. He liked to work in series, he tackled the major issues of the day such as President Nixon's visit to China in the *Mao* portraits. He explored controversial subjects (transvestism in *Ladies and Gentlemen*, bodily fluids in *Oxidation*), he turned to the centrality of economic life (*Dollar Signs*), and, again and again, he painted portraits, mostly commissioned, of the rich and famous of the day. This 'portrait' of an era had its written equivalent in Warhol's very own celebrity magazine, *Interview*, which was published throughout the 70s and 80s [10]. In the second half of the 1970s death became an obsessive issue in Warhol's work. His series of *Skull Paintings* and his *Self-portraits with Skulls* of 1976 and 1978 no doubt reflected the black imagery of punk culture,[17] but they have both a more personal and a more universal significance. In 1968 Warhol had almost died from gunshot wounds inflicted by the radical feminist writer Valerie Solanas. The attack had a profound impact on Warhol and his work. The skull is also a common *memento mori* ('remember you must die') symbol in Western art, used by saints and other religious figures as aids to meditation. Warhol was a devout Catholic attending church, (although not taking Communion) every Sunday, and was well aware of the skull's religious overtones. The late 1970s were a famously licentious time in New York, as various sexual liberation movements made people less inhibited in their sexual behaviour and the threat of HIV / AIDS had not yet revealed itself. Catholic doctrine, however, had not changed and still taught that the wages of sin were death. This all resonates in these powerful paintings. But Warhol was no preacher and took a more rounded view. The skulls cast a shadow to the left that takes on the profile of a baby or foetus thus suggesting a less final and more cyclical view of life and death. The colours in which the skulls are painted are also more suited to the candy and ice cream store than to the morgue. Death here is a natural part of life rather than an apocalyptic finale.

More mysterious and ambiguous was a series called *Shadow* that Warhol painted a couple of years later in 1978. These essentially abstract paintings were made using a photographic image of shadows cast by a small, specially constructed model (of nothing in particular). Because the shadows are not specific, they tend to suggest an unknown presence, such as death. Warhol made a large number of these paintings in a variety of colours and many of them the same size. He intended these to be seen as an installation,

closely butted up against each other and forming an uninterrupted wall of colours and numinous shadows surrounding the viewer. This work (for it can be viewed as a single work of art) remains one of Warhol's most powerful and enigmatic statements on the theme of death.

In the early 1980s Warhol's take on death became much more specific and object-based. The crosses [11], guns [78] and knives series of 1981 leave no doubt about their subject matter. The paintings that Warhol made in 1985 and 1986, right at the end of his life, however, are in turn blacker and bleaker and suggestive of a simpler, more naïve faith in personal salvation. The works based on adverts and illustrations in newspapers are nearly all black and white and most were conceived as diptychs, often in positive and negative

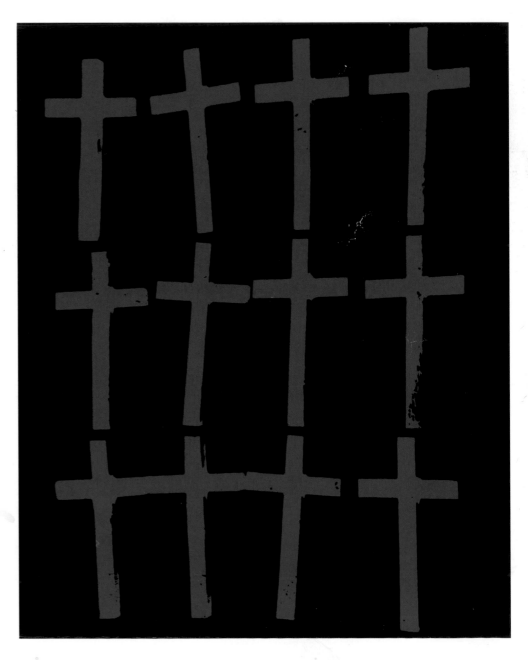

form. War (the renewed Cold War of the Reagan era), death, and religion are the main subjects. The 'Evil Empire' rhetoric about the Soviet Union inspired Warhol's *Map of Eastern U.S.S.R. Missile Bases* [**81**] and the war theme is taken up in the work *Paratrooper Boots* [**83**]. Death and religion are the subject of *Christ $9.98* [**79**], *Repent and Sin No More!* [**84**], *The Mark of the Beast* and *Heaven and Hell are just One Breath Away!* The positive / negative, black / white diptych-form underlines not only the geo-political polarities of the Reagan era, but also the religious certainties of the neo-conservatives and born-again Christians. The paintings are like banner headlines screaming their unequivocal messages at us. The *Camouflage* paintings of 1986 [**85**], by contrast, constantly elude certainties. Used by the military in order to

is altogether more mysterious: a hidden god rather than a revealed god. With hindsight we know that Warhol was to die only a matter of weeks after he finished these paintings. However, we also know that his inflamed gall bladder had been causing him pain for some time and this pain eventually forced him to book into a New York hospital. It is, therefore, not idle speculation to see both the *Camouflage* and *Last Supper* series, as an attempt on Warhol's part to meditate on death, God, and a possible afterlife.

This vision of death is much more differentiated and personal than the media-saturated world of Marilyn Monroe or President Kennedy's death. It has none of the clinical finality of the death and disaster paintings. In similar fashion the *Mao*, *Hammer and Sickle* and *Dollar Sign* paintings

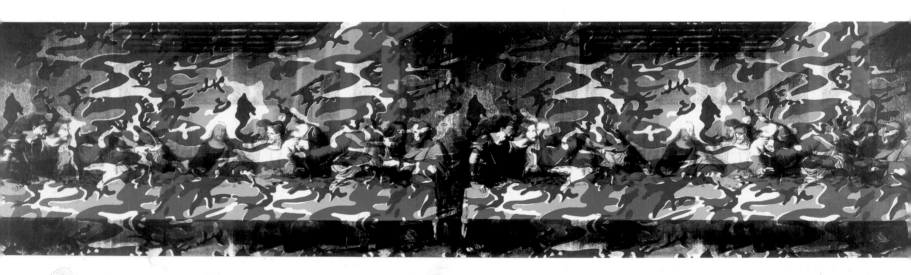

11 | CROSSES (TWELVE)
1981–2

Acrylic and silkscreen ink on linen 50.8 × 40.6cm
The Andy Warhol Museum, Pittsburgh, Founding Collection, Contribution The Andy Warhol Foundation for the Visual Arts, Inc.

12 | CAMOUFLAGE LAST SUPPER 1986

Synthetic polymer paint and silkscreen ink on canvas 198.1 × 777.2cm
The Menil Collection, Houston, gift of Contribution The Andy Warhol Foundation for the Visual Arts, Inc.

deceive the eye and hide things away, camouflage patterns and colours vary according to the type of surroundings: khaki and green for lush vegetation, beige and ochre for desert conditions. Warhol used both of these colour patterns, but he also used bright primary colours as well. Are these meant to be modern, urban camouflage colours designed to disguise those who wish to blend in at the disco, department store or restaurant? Or, are they the chameleon-like colours of a god who can be found everywhere, in all habitats and milieus? Warhol used camouflage colours in several of his *Last Supper* paintings of 1986 [**12**]. The *Last Suppers* were based on cheap reproductions of Leonardo da Vinci's mural, *The Last Supper*, in Milan. The simple faith of millions of Catholics is sustained by this iconic image hanging on the walls of their homes. In his camouflage version, Warhol removes the clarity and simplicity of the image. Christ is no longer the unambiguous saviour of the world, sacrificing himself for the sake of us poor sinners, but

have none of the brash optimism and clear-eyed conceptualism of *Campbell's Soup Cans* and *Brillo Boxes*. Warhol's view has broadened out and is taken from a more distant vantage point. Nearer as this vantage point came to his ultimate death in the 1980s than in the 1960s, it is not surprising that death rather than life became the subject of most of his late paintings.

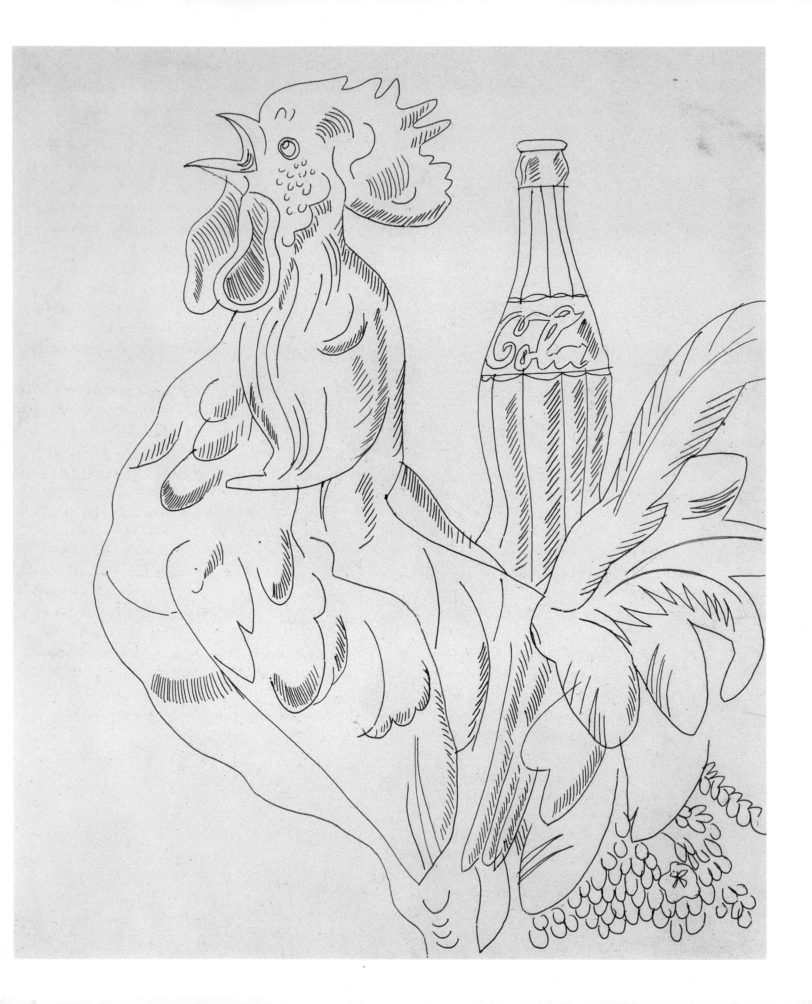

When Andy Warhol arrived in New York from Pittsburgh in 1949, seeking work as a commercial illustrator, Abstract Expressionism was establishing itself as the dominant movement in the city and artists, such as Jackson Pollock, who frequented the Cedar Bar, exuded a hard-drinking, macho image to go with it. In almost all respects Warhol could not have been more different. As a commercial artist he would have been looked down upon by those producing 'real', soul-searching art. Even the drawings that he made to sell, to give as gifts or for his own pleasure were, for the most part, witty, light-hearted, whimsical, decorative and full of fantasy; above all, they were figurative, rarely abstract.

The coloured drawing *Happy Butterfly Day* [**15**] is typical of this type of work. Many of the drawings were created by a form of printmaking, called the 'blotted-line' technique. Warhol would draw freehand or trace a drawing in ink on a

Early Drawings

piece of paper, which he would then 'blot' onto another piece of paper. Carefully retracing the same drawing, Warhol could make several more 'blots' to repeat the image – in effect a series of prints. Warhol worked in this way for several reasons. The most important was that he liked the rough ('raggedy'), spontaneous feel of the line (in this respect, at least, he was a true contemporary of the Abstract Expressionists). He also liked the fact that the final drawing was at one remove from himself, from his own 'handwriting'. The process was objectifying and mechanical. It made the things that he depicted look less like his own creations and more like anonymous, found illustrations. This was an approach that would find its almost perfect technique when Warhol discovered screenprinting in the early 1960s.

Although the drawings that Warhol made in the 1950s seem, at first sight, to have little connection with the work that he did in the 1960s and afterwards, there are, in fact, important similarities and signs of his future developments. Warhol's supreme interest in fashion, in what was up to date and of the moment, emerges very strongly. Of course, this was closely linked to the illustrations that he was doing for fashion houses and clothes manufacturers (particularly of shoes). See, for example, drawings like *Blue Shoe* [**3**], *Six Handbags* [**16**], and *Female Figures and Fashion Accessories* [**17**].

These still have the feeling of elegant, promotional illustrations, albeit leavened by a sense of wit and whimsy, but they show Warhol's intense interest in the world of surfaces, of appearances, of real (if privileged) life.

The drawings that Warhol did as proposed illustrations for books show his interest in the darker side of modern American life. The drawing of a drug-injecting young man that he made for *The Nation's Nightmare* [**4**] looks forward to some of the films that Warhol would make in the mid-1960s and to the drug culture that reigned in The Factory during those years.

In the line drawings from the mid-to late 1950s that Warhol did of young men, clothed and unclothed, we can already see his voyeuristic interest in the male body that would culminate in such movies as *Sleep* made in 1963 and which consists of eight hours of film concentrated on the sleeping, naked body of the poet John Giorno. Warhol always insisted that intense concentration on a single thing, such as a body, drained it of content, so that the end result was in large measure abstract. This is certainly true of *Sleep* and other Warhol films, but it is equally true of his early drawings, such as *Boy Licking his Lips* [**19**] and *Boy with Stars and Stripes* [**18**]. The more one looks at these works the more the facial features and hair break down into individual, decorative features, into repeated abstract shapes.

Already by 1959 and 1960 Warhol's drawings were beginning to include branded products, such as a Coca-Cola bottle in *Rooster with Coca-Cola Bottle* [**13**] and iconic American symbols, such as the American flag in *Boy with Stars and Stripes* and to presenting them in pared-down simplicity, as symbols of an optimistic, prosperous society. Pop Art had almost arrived.

13 | ROOSTER WITH COCA-COLA BOTTLE 1960
Ink on manila paper 42.5 × 35.2cm
Scottish National Gallery of Modern Art, Edinburgh,
on loan from a Private Collection

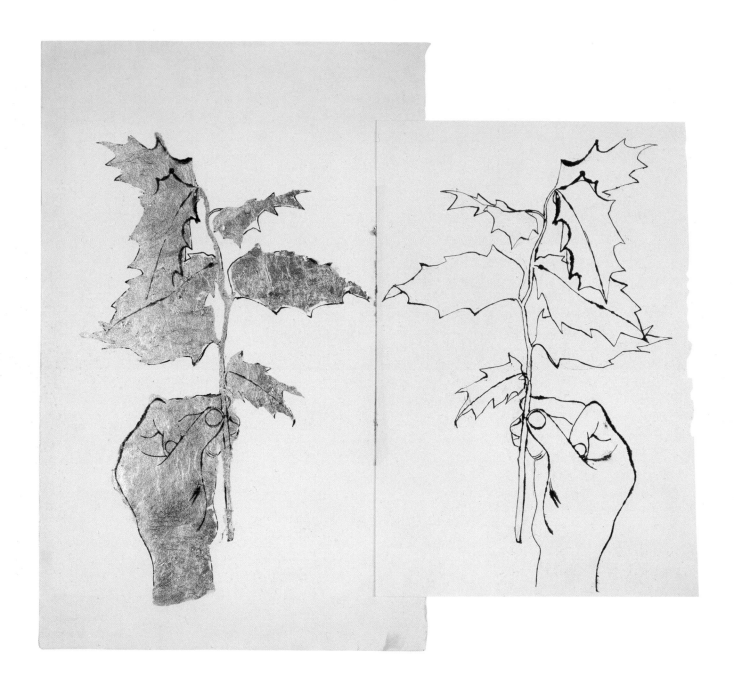

14 | HAND HOLDING LEAFY BRANCH 1957

Ink and gold leaf on paper
Two parts, each 58.1 × 61.6cm
Scottish National Gallery of Modern Art, Edinburgh,
on loan from a Private Collection

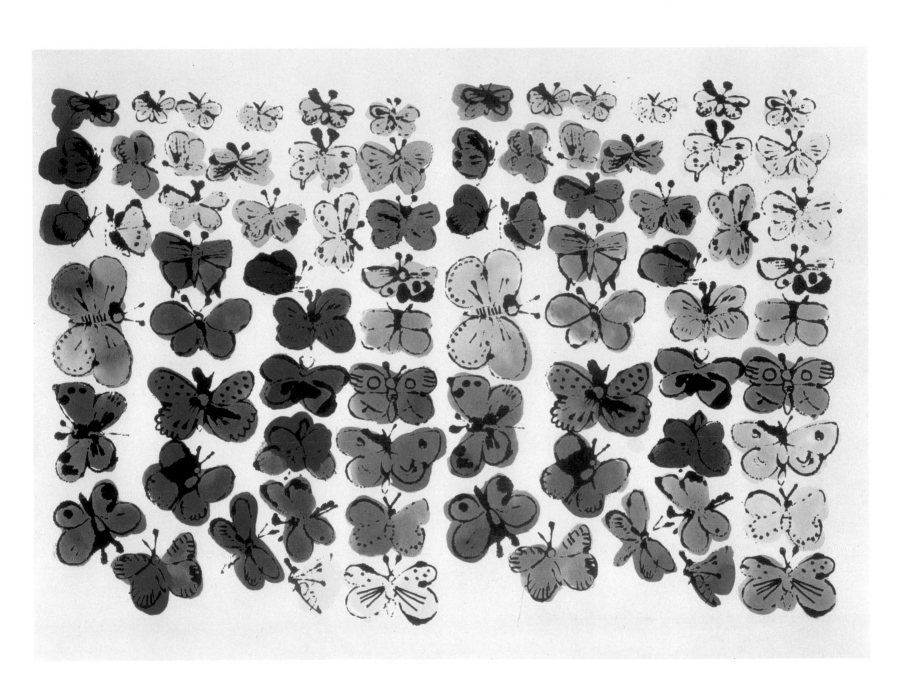

15 | HAPPY BUTTERFLY DAY 1955

Ink, graphite, and Dr Martin's Aniline Dye on Strathmore paper
33 × 45.7cm
Scottish National Gallery of Modern Art, Edinburgh,
on loan from a Private Collection

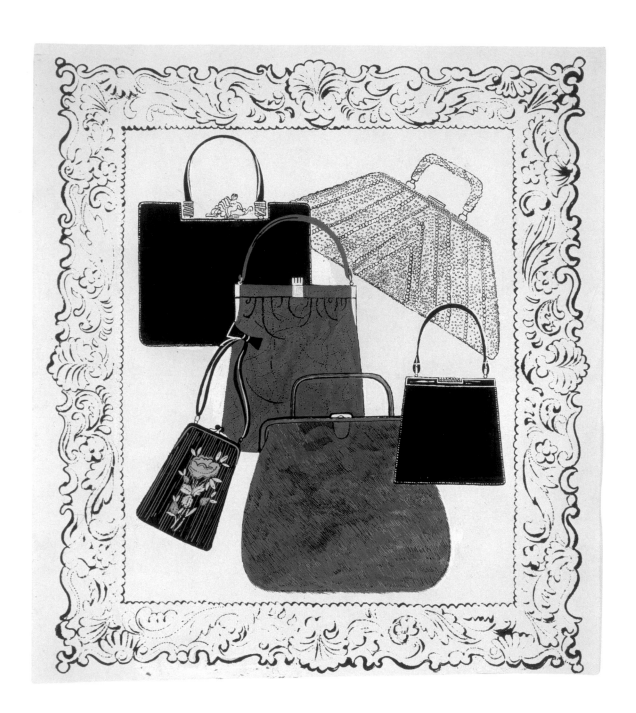

16 | SIX HANDBAGS 1958

Ink and tempera on Strathmore paper 34 × 33cm
Scottish National Gallery of Modern Art, Edinburgh,
on loan from a Private Collection

17 | FEMALE FIGURES AND FASHION ACCESSORIES 1960
Ink and Dr Martin's Aniline Dye on Strathmore paper on board 47 × 66cm
Scottish National Gallery of Modern Art, Edinburgh,
on loan from a Private Collection

18 | BOY WITH STARS AND STRIPES 1959

Black ink on manila paper 42.9 × 35.2cm
Scottish National Gallery of Modern Art, Edinburgh,
on loan from a Private Collection

19 | BOY LICKING HIS LIPS 1956

Ink on paper 42.2 × 35.2cm
Scottish National Gallery of Modern Art, Edinburgh,
on loan from a Private Collection

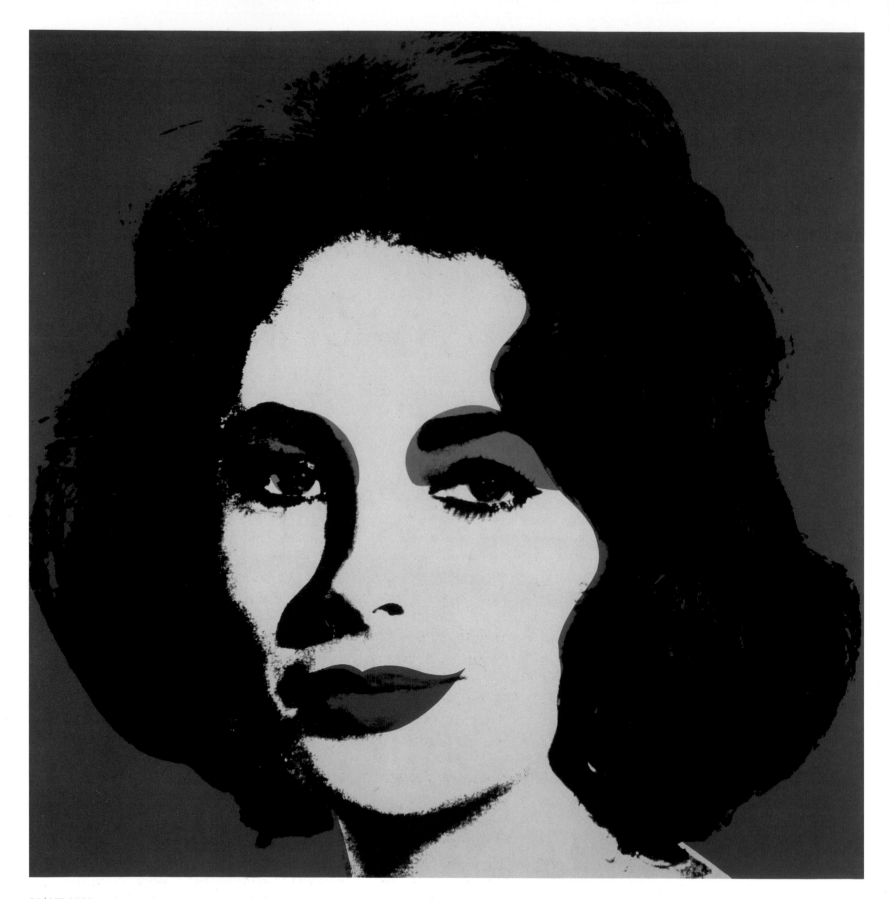

20 | LIZ 1964

Offset lithograph on paper 58.7 × 58.7cm
The Andy Warhol Museum, Pittsburgh, Founding Collection,
Contribution The Andy Warhol Foundation for the Visual Arts, Inc.

On 5 August 1962 Marilyn Monroe committed suicide. At the time she was one of the biggest stars of Hollywood – beautiful, sexy, vulnerable – and she seduced a whole nation when she sang 'Happy Birthday' to President Kennedy on live television. But nothing became her more than her death. This raised her to iconic status; and Andy Warhol's paintings of her, begun only weeks after her death, did more than anything else to provide the world with the iconic image needed for her cult status. One of the earliest and most iconic paintings that Warhol did of Marilyn is the so-called *Gold Marilyn* [2], in which her face is isolated in the middle of a large gold-painted canvas. It is, in fact, very like a religious icon, the sort of paintings that are displayed in Orthodox Churches in Russia and Eastern Europe. Warhol had grown up as a Byzantine Catholic, attending church in Pittsburgh that had an iconostasis of images of Christ, Mary and the saints that served as an aid to worship. As a boy

Portraits of the 60s

Warhol had also worshipped at the altar of Hollywood and venerated its stars, such as Shirley Temple. He had collected publicity photographs of his favourite actors and actresses. It is not difficult to see how the two – Catholic faith and a love of Hollywood – could contribute to a new type of celebrity image.

The technical prerequisite for the Marilyn work and other celebrity paintings was the use of photo-screenprinting. This enabled Warhol to use pre-existing photographic images – in the case of Marilyn Monroe, a cropped publicity photograph – which could be enlarged and transferred to a silkscreen. This was the basis of all the subsequent images, which would vary according to how heavily or thinly the screens were inked and if they got clogged through inadequate cleaning between each application of ink. This can clearly be seen on the right half of the magisterial *Marilyn Diptych* [21]. Some of the heads are so heavily inked that Marilyn's facial features disappear behind a black pall; in others, so little ink is used that her face is washed out and fades into the light background. By painting one half of the diptych in bright garish colours and the other in black and white, Warhol suggests a life / death split between the two halves, although not in a crass, formulaic way. The row upon row of repeated heads call to mind postage stamps, bill-

board posters, but, perhaps, most of all, and most appropriately, strips of film. This effect is heightened by the fact that, although each head is based on the same screened image, the inking varies. This creates the effect of a head filmed over time and changing imperceptibly each time. The *Marilyn Diptych* is both celebratory of a life and a mourning of a death. Warhol said that he only became aware that he was treating the theme of death, after he had painted the pictures of Marilyn and was doing other similar portraits. For example, he only started to paint Elizabeth Taylor when she was seriously ill and was in danger of dying. The *Silver Liz* paintings, in particular, have a strong feeling of a past legend of the silver screen, rather than a vital force in contemporary films [23]. Even the painting of Elvis Presley in *Double Elvis* [22] shows the star pointing a gun at us. The overlapping of two repeated images creates a sort of stroboscopic effect, a sense of movement in the figure of Elvis, which makes the presence of the gun more threatening.

One of the most traumatic events of the postwar era, not only for America but for the rest of the world, was the assassination of President John F. Kennedy in Dallas on 22 November 1963. Warhol, like many Americans, followed the unfolding events on television and decided soon after that he wanted to paint a series of pictures around the assassination. After gathering press photographs over the subsequent weeks, he decided to use the figure of Jackie Kennedy as a focus for the event. Indeed, as time went on, and he put together the images of Jackie that he wanted to use, reversing several of them in the process, Warhol moved further and further away from the specific assassination to a more generalised study of happiness, subsequent grief and final dignity. Jackie was like a heroine in a Greek tragedy, a timeless figure that we all came to admire and empathise with.

Warhol chose a limited number of images of Jackie Kennedy, but made a large number of small paintings to be shown either individually or joined together as part of composite pictures [24]. There were images of her before the assassination, images of her when Lyndon B. Johnson was sworn in as president, and images of her as the dignified widow during the funeral ceremony. As with Marilyn it was Warhol's images of Jackie Kennedy that came to represent her to the general public and it shows Warhol's uncanny ability to fix an image in our mind by capturing the mood of the moment.

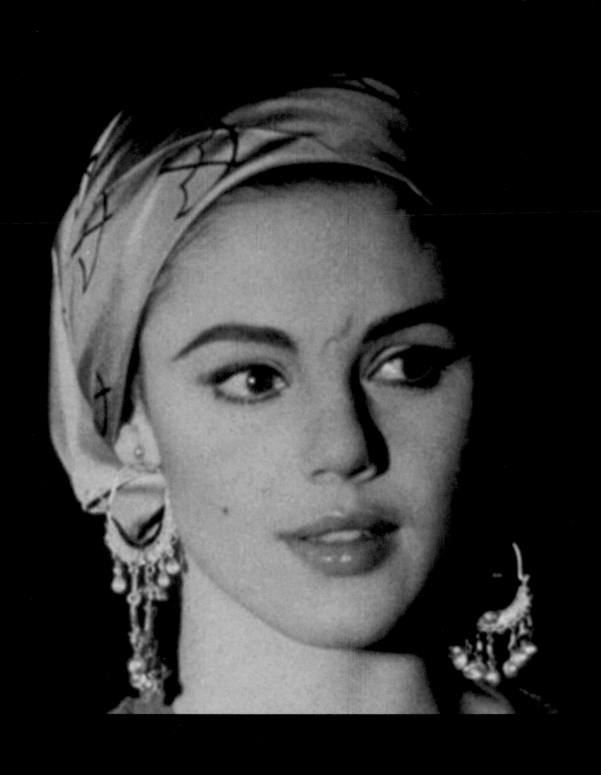

Screen Tests

25 | EDIE SEDGWICK 1965

Edie Sedgwick was one of Warhol's greatest
stars. She became a style icon and played a
crucial role in Warhol's emergence as a
celebrity in the mid-1960s. Between March and
September 1965, Sedgwick appeared in every
film Warhol made with sound. Warhol recalled:
'Edie was incredible on camera – just the way
she moved ... She was all energy – she didn't
know what to do with it when it came to living
her life, but it was wonderful to film. The great
stars are the ones who are doing something you
can watch every second, even if it's just a
movement inside their eye.'

16mm film, black and white, silent 4 minutes at
16 frames per second

Closely related to Warhol's multiple portraits are his *Screen Tests*,
short three-minute, silent films that he began shooting in 1964.
Warhol acquired an H-16 Bolex film camera in early summer 1963
and in the same year made films like *Sleep*, *Haircut* and the series
Kiss, which were based more on one powerful idea than on a plot.
To all intents and purposes the *Screen Tests* were film portraits. The
sitters – Factory regulars and beautiful and / or interesting visitors –
were asked to sit in front of a screen looking directly at the camera
without moving. Some of the sitters could sit so still, barely blink-
ing, that people who saw the films thought they were freeze-frames
or photographs. Other sitters played up to the camera, assuming
different poses and acting out different emotions (see especially
Susan Sontag). The set-up was very similar to the photo-booth
photographs that Warhol had used for such paintings as *Ethel Scull
36 Times* [9]. He had posed Scull and other sitters in a photo booth
and asked them to assume various poses and expressions. The
composite paintings that resulted from these sessions recorded
these changing faces across the canvas, thus introducing the
element of time into the works. It was but one step from this
procedure to the *Screen Tests*.

The idea of the screen test was, of course, not new. It was the
standard Hollywood method of seeing if someone would look good
in film. People could look beautiful in life, even in still photographs,
but they would not necessarily look beautiful on film. Warhol liked
the idea of making The Factory into a mini-Hollywood and seeing
who would be usable in the films he was making. But there was
another idea behind the *Screen Tests*, at least in the beginning. He
wanted to do a series of *Screen Tests* which he would call *The Thirteen
Most Beautiful Boys* and which were produced from 1964 to 1966. The
idea was based on leaflets put out by the New York City Police
Department, called *The Thirteen Most Wanted*, which contained mug
shots (full face and profile) of thirteen men wanted by the police.
Warhol had used these images for the short-lived mural he had
made for the exterior of the New York State Pavilion at the 1964
World's Fair in Queens, and for a subsequent series of double
portrait paintings, called *Thirteen Most Wanted Men* [8]. It was the
alternative meaning of 'wanted' that lay behind Warhol's series of
Screen Tests, *The Thirteen Most Beautiful Boys*. Other series of *Screen Tests*
followed: *The Thirteen Most Beautiful Women*, *Fifty Fantastics and Fifty
Personalities*, and *Six Months* (a 'portrait' of Philip Fagan, made up of a
series of daily screen tests taken over six months). The conceptual
underpinning of the individual screen tests and of the series lay in
the notion of duration and comparison. How do people's faces
change over time? How do their faces mirror their emotions? Is
there such a thing as a constant, unchanging self? How do people's
faces differ? How can one define beauty? Is there a common factor?

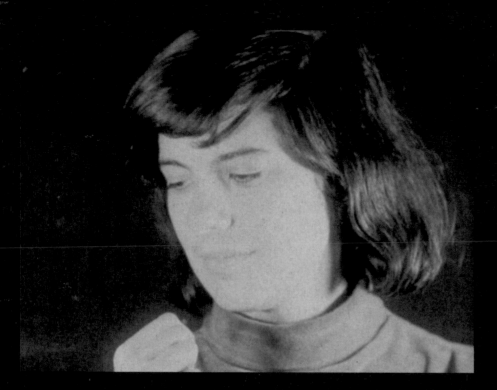

opposite

26 | LOU REED 1966

The musician and writer Lou Reed was the lead singer in The Velvet Underground, the band which Warhol began to manage in 1966. Reed produced his first solo albums in 1972 and collaborated with fellow Velvet Underground member John Cale in 1989 to record Songs for Drella, a musical biography of Warhol. Reed appeared in eleven *Screen Tests* and several other Warhol films. The *Screen Tests* were mainly intended for projection behind The Velvet Underground during their multimedia 'Exploding Plastic Inevitable Performances'. Like Nico, Reed was also filmed with commercial products in some of his *Screen Tests*.

16mm film, black and white, silent 4 minutes at 16 frames per second

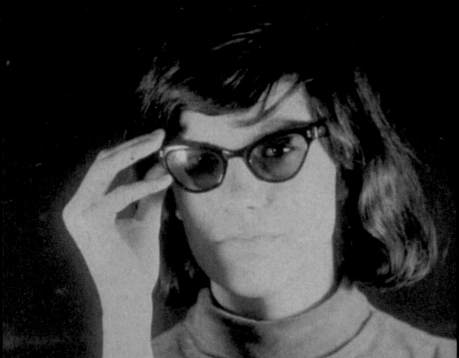

27 | SUSAN SONTAG 1964

Sontag's innovative essay *Notes on 'Camp'* was published in 1964, introducing the term into everyday society where it became confused with Pop. The essay inspired Warhol to make the film *Camp* in 1965. She appears in seven *Screen Tests*, which were apparently filmed over seven different sessions and in which Sontag explores a variety of personas in front of the camera. Warhol considered that she had, 'a good look – shoulder-length, straight dark hair and big dark eyes, and she wore very tailored things'.

16mm film, black and white, silent 4 minutes at 16 frames per second

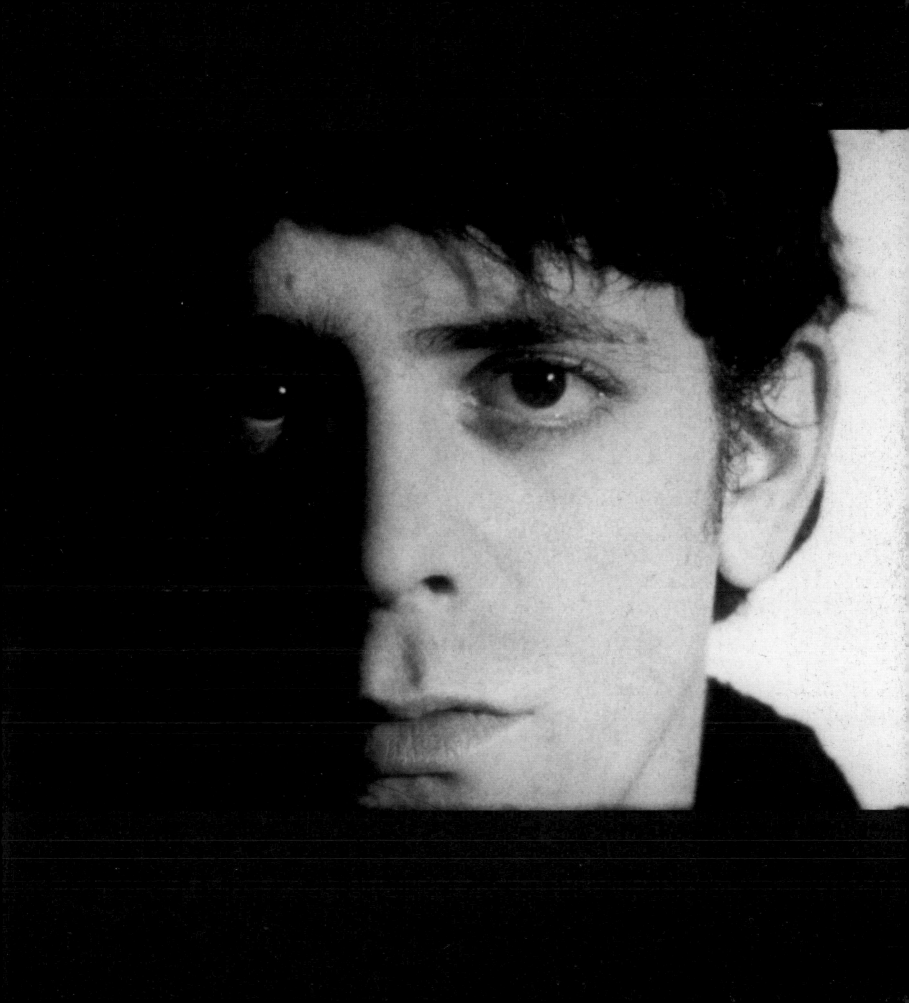

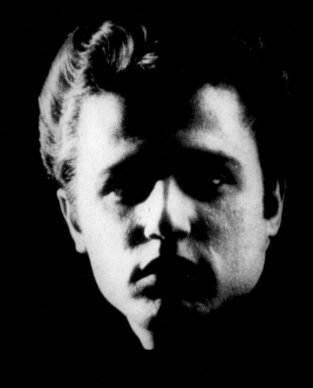

28 | GERARD MALANGA 1964

The young writer Gerard Malanga was Warhol's chief studio assistant from 1963 until 1970. In addition to the *Screen Tests*, Warhol cast him in many of his 1960s films. In his portraits he remains still, looking directly into the camera. Malanga produced *Screen Test Poems* in 1966, a performance combining projections of the *Screen Tests* with readings of his poetry. In 1967 he collaborated with Warhol on *Screen Tests / A Diary*, which incorporated stills from the *Screen Tests* alongside poetry by Malanga.

16mm film, black and white, silent 4 minutes at 16 frames per second

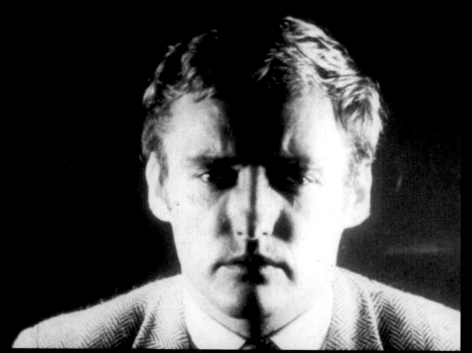

29 | DENNIS HOPPER 1964

Actor and filmmaker Dennis Hopper purchased a Campbell's Soup Can painting from Warhol's solo exhibition at the Ferus Gallery in Los Angeles in 1962. His *Screen Tests* were probably filmed during his visit to The Factory to appear in Warhol's film *Couch*. Hopper's professional experience is apparent in his *Screen Tests*. He recalled: 'I was in another film that Andy did called *The 13 Most Beautiful Boys in the World* ... Andy just told me the title and turned on the camera and walked away ... [B]eing the egomaniac that I am, I sat there and did a Strasbergian emotional memory.'

16mm film, black and white, silent 4 minutes at 16 frames per second

30 | NICO 1966

Born Christa Päffgen, Nico grew up in Germany before moving to Paris in 1956. She appeared in Federico Fellini's film, *La Dolce Vita*, in 1960 and took the lead role in Jacques Poitrenaud's film, *Striptease*, in 1963. She met Warhol in 1965 and he arranged for her to sing with The Velvet Underground during their first public performances and later on their first album, *The Velvet Underground and Nico*, which was released in 1967. She appeared in many of Warhol's films and sat for ten *Screen Tests* including four pseudo 'commercials' where she appears with beer, Coca-Cola and Hershey's chocolate.

16mm film, black and white, silent 4 minutes at 16 frames per second

31 | INGRID SUPERSTAR 1966

Ingrid Von Scheven began to frequent The Factory in 1965. She was initially thought by many to be a replacement for Edie Sedgwick who had become somewhat estranged from The Factory. Warhol recalled: 'Ingrid was just an ordinary nice-looking girl from Jersey with big wide bone structure posing as a glamour figure and a party girl, and what was great was that somehow it worked ... It was so funny to see her sitting there on the couch next to Edie or, later, Nico and International Velvet, putting on makeup or eyelashes exactly the way they did, trading earrings and things and beauty tips with them. It was like watching Judy Holliday, say, with Verushka.'

16mm film, black and white, silent 4 minutes at 16 frames per second

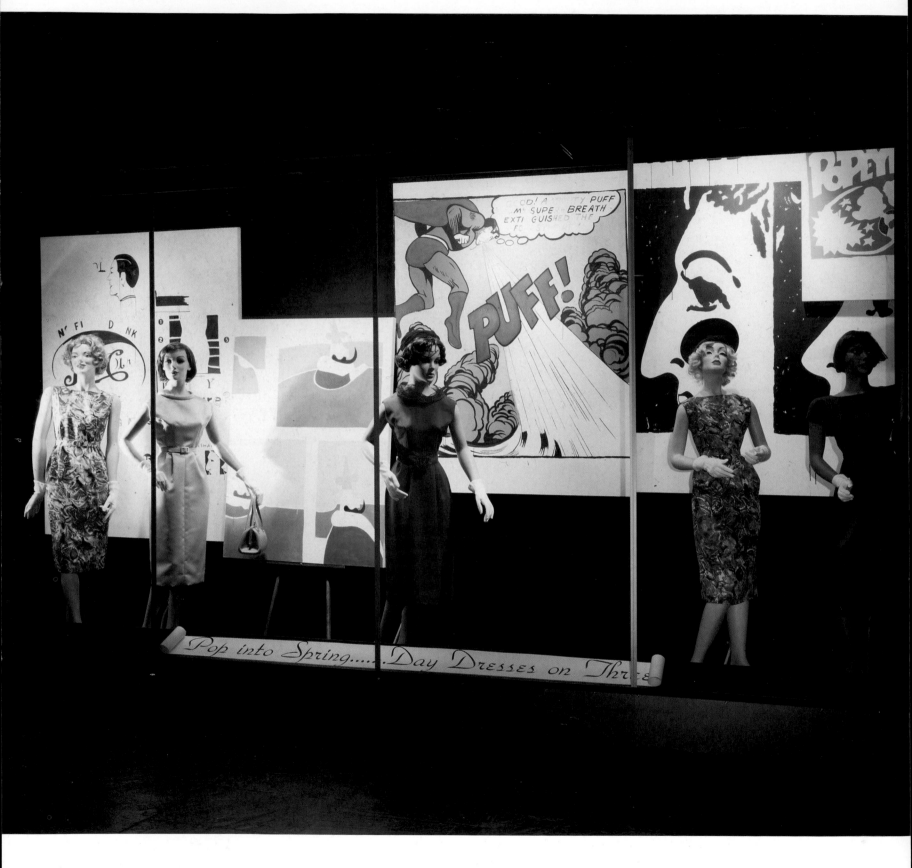

32 | **BONWIT TELLER WINDOW** 1961

Recreation for *The Warhol Look*, 1999,
The Andy Warhol Museum, Pittsburgh, Founding Collection,
Contribution The Andy Warhol Foundation for the
Visual Arts, Inc.

As a highly successful commercial illustrator Warhol knew the power of branding, advertising, marketing, and display. He decided to move to 'fine' art from 'commercial' art just as photographically-based adverts were beginning to take over from hand-drawn adverts, which were his own speciality. After doing a small number of comic-strip paintings (which he felt were too similar to the paintings of Roy Lichtenstein), Warhol began in 1960 to use adverts for various products – a fridge, a water heater, an electric drill, a plumbing pipe, a can of Del Monte peach halves and a Coca-Cola bottle – as a basis for paintings. They were made by making tracings from the adverts and then projecting the resulting images onto canvas for 'copying' in paint. This development in Warhol's work can be seen in the paintings he chose for a window display in Bonwit Teller's department store in New York in April 1961. The display included both comic strip and ad paintings and formed a backdrop to a group of female

Consumer Products

mannequins wearing fashionable summer clothes. It is significant that the first time that these ad paintings were shown was in a blatantly commercial setting [32]. Warhol wanted to celebrate the modern, commercial world, the world that had provided prosperity for postwar America, the world that he knew from his commercial background and from his own experiences as a consumer. But the way that these works were painted – by hand, in a painterly style, complete with drips – meant that they looked like still lifes at worst, and like documentary reportage at best. The objects failed to take on an iconic quality. This he really achieved after he began to adopt a hard-edged, radically simplified treatment of the products he painted, with no sense of ambient space or shadows. This happened in 1962 when he painted his famous *Campbell's Soup Can* series. The thirty-two paintings of Campbell's soup cans, each a different type of soup, that he made for the Ferus Gallery in Los Angeles, are not only iconic in their treatment, they also take on the appearance of readymades [5]. The French / American Dadaist, Marcel Duchamp, had famously taken readymade objects such as a urinal or a snow shovel and declared them to be works of art. If Duchamp's actions had been iconoclastic, Warhol's were more celebratory. His paintings made the point that, just as consumer products

such as soup cans could be manufactured *ad infinitum*, so could his paintings of the soup cans be a multiple. The Pop Art revolution lay in aping the mass production methods of modern manufacturing.

Warhol took this to its logical conclusion in 1964 when he made his *Brillo Boxes* (and other boxes) [33, 35–8]. By this time he had learnt how to use photo-screenprinting techniques to transfer the photographs of products onto the surface of the art object. The boxes were made out of wood. They were then painted and finally the branded lettering and design were silkscreened onto the surface. Piled up in stacks they looked like the products they represented. The Stable Gallery, in which they were first displayed, resembled a supermarket. Warhol was playing a clever game. He was puncturing the elitist notions of the unique work of art in two ways: first, by choosing a product that was so banal and everyday that it was usually overlooked; second, by making the work of art an infinitely extendable multiple. In effect, what he was saying was that life and, in particular, modern life was worthy of our close attention and that art should not treat it in an elitist way, because by doing so we would be belying its very modernity. The repercussions of Warhol's actions are still being felt today.

33 | BRILLO BOXES 1968
Synthetic polymer paint and silkscreen ink on wood
Ten boxes, each 43.2 × 43.2 × 43.2cm
Scottish National Gallery of Modern Art, Edinburgh,
on loan from a Private Collection

34 | DOLLAR SIGN 1982
Acrylic and silkscreen ink on canvas 228.6 × 177.8cm
Scottish National Gallery of Modern Art, Edinburgh,
on loan from a Private Collection

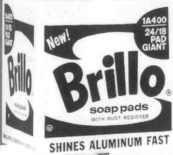

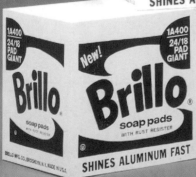

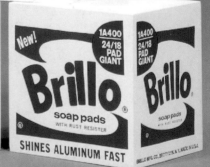

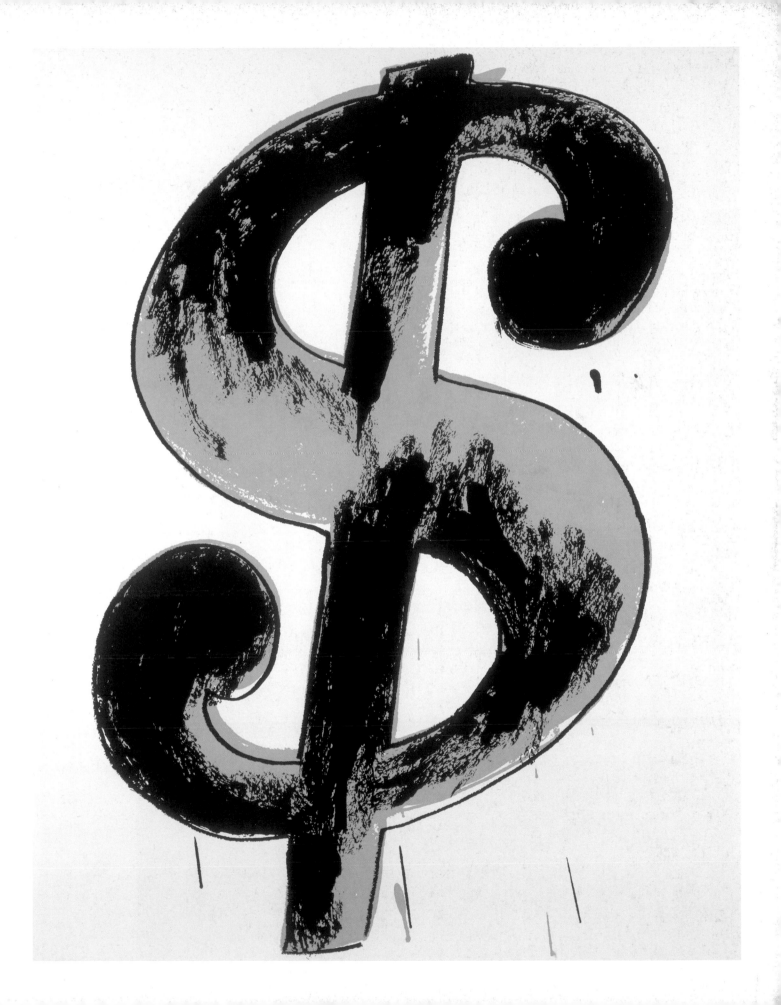

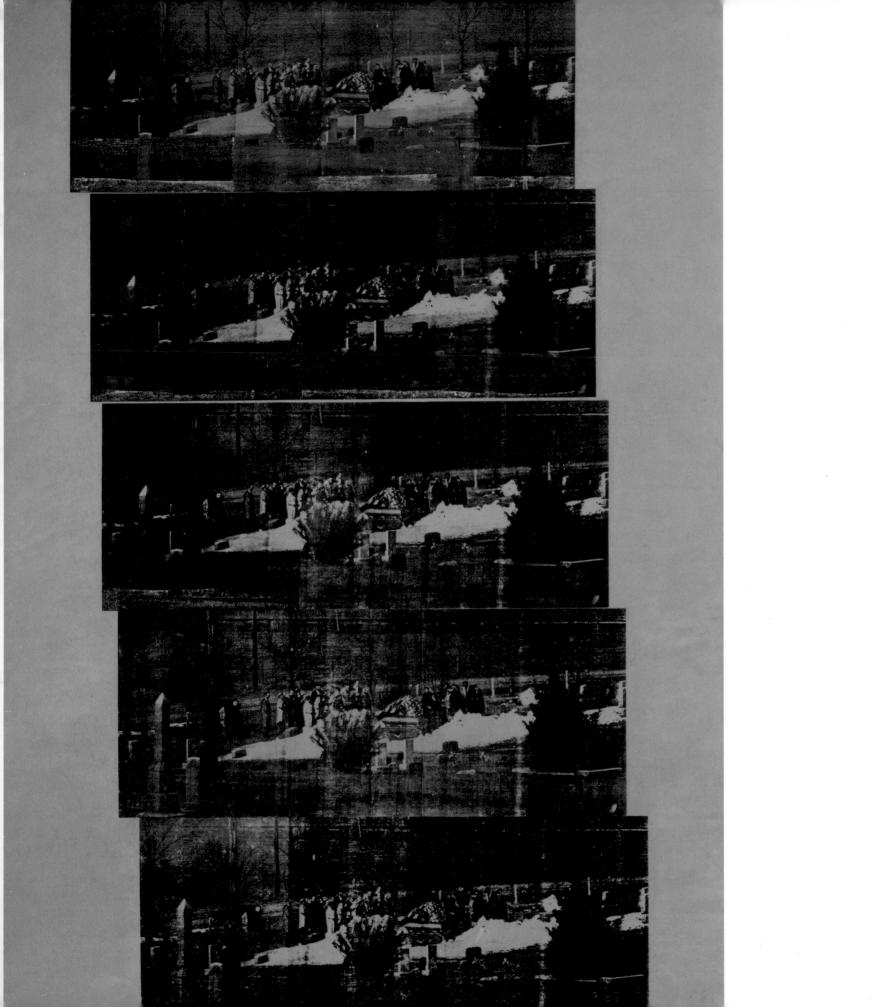

Death and Disaster

Warhol's death and disaster paintings are a series of works begun late in 1962 and which continued into the mid-1960s. The subjects treated include car crashes, suicides, hospital scenes, funerals, electric chairs, race riots, poisonings and the atomic bomb. It seems that the series was suggested in the summer of 1962 by Warhol's friend, Henry Geldzahler, the curator for modern and contemporary art at the Metropolitan Museum of Art in New York, who showed Warhol the front page of a newspaper bearing the photograph of a plane crash and the banner headlines, '129 DIE IN JET' [6]. He felt that Warhol had done enough extolling of modern American life and should now turn to death in America.

The series of paintings that ensued are among the most powerful and searing works that Warhol ever made. They are based on press photographs that were sometimes published in newspapers and magazines. The American public had an appetite for photographs of gory events and Warhol was no exception. He chose some of the most brutal scenes that could be published: images of suicides actually falling from high-rise buildings [42]; dogs attacking Civil Rights protestors; a shoe protruding from beneath a heavy tyre [40]; a man pinioned to a telegraph post, having been thrown onto it by the force of a car crash; and views of an empty electric chair with a notice saying 'SILENCE' on the wall behind.

These disturbing and poignant images are silkscreened onto the canvases, usually in multiple form. The more the images are repeated across the canvas, the less easy it becomes to read them, with the result that our shock at finding out the grisly subject matter is delayed. The repetition also serves to empty out the meaning of the image. Death, even a violent death, becomes banal, an everyday occurrence in America. When colour is used, as in *Gangster Funeral* [39] or *Lavender Disaster* [7], the shades are often somewhat acid or subdued, adding to the melancholy mood of the paintings. Because of the hard-hitting, no-holds-barred nature of these paintings, perhaps, also in view of the fact that America was still hurting from the assassination of President John F. Kennedy, Warhol did not show the disaster pictures at first in the United States, but in Paris, at the Galerie Ileana Sonnabend in January 1964. They made a huge impact and established Warhol as a serious artist, dealing with serious subject matter.

39 | GANGSTER FUNERAL 1963

Acrylic, silkscreen ink, and graphite on linen 266.7 × 192.1cm
The Andy Warhol Museum, Pittsburgh, Founding Collection,
Contribution Dia Center for the Arts

42 | SUICIDE (SILVER JUMPING MAN) 1963

Silkscreen ink and silver paint on linen 114.3 × 208.3cm
The Andy Warhol Museum, Pittsburgh, Founding Collection,
Contribution The Andy Warhol Foundation for the
Visual Arts, Inc.

43 | WHITE BURNING CAR III 1963

Silkscreen ink on linen 255.3 × 200cm
The Andy Warhol Museum, Pittsburgh, Founding Collection,
Contribution Dia Center for the Arts

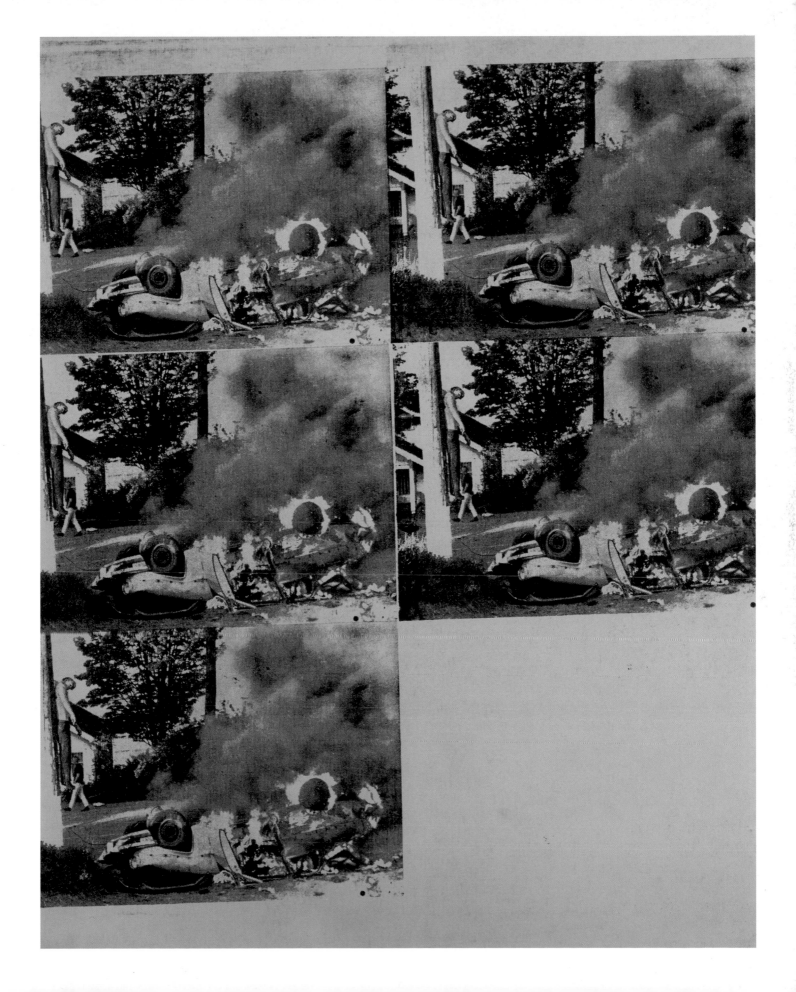

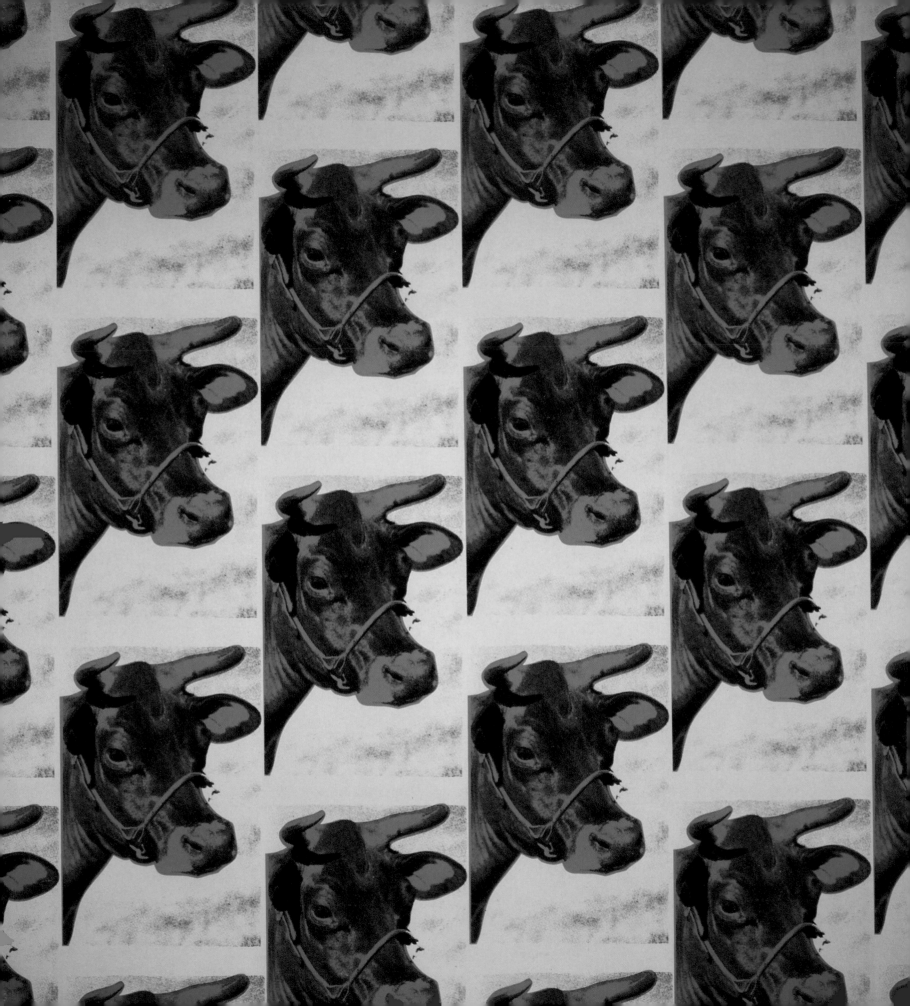

Installations

Warhol never liked to confine his artistic talents to any one medium. Having established himself as a painter in the period 1960–3, he turned to sculpture in 1964 when he made his first *Brillo Boxes*. The way that he displayed them at the Stable Gallery, New York in 1964, in huge piles, so that people had to thread their way between them as if they were in a supermarket aisle, also shows that Warhol had a keen eye for what would later become known as 'installation'.

In 1966 at the Leo Castelli Gallery in New York Warhol showed his *Silver Clouds* and his *Cow Wallpaper* for the first time (in different rooms). The *Silver Clouds* were made of a silver material called Scotchpak that could be inflated using a helium / air mixture so that they floated midway in the gallery space. Warhol had had the idea for making the clouds in 1964, probably after meeting Billy Klüver, an engineer. The idea was for the clouds to activate the space, reflecting the surroundings and the people in it. In 1968, the renowned choreographer Merce Cuningham used Warhol's *Silver Clouds* in his dance *RainForest*.

Just as the *Silver Clouds* picked up on the space-filling installation of the *Brillo Boxes*, so the *Cow Wallpaper* picked up on a previous exhibition at the Leo Castelli Gallery in 1964 when he had installed flower paintings from floor to ceiling, covering as much wall space as possible. The idea for making a work using the image of a cow seems to have come from Ivan Karp who worked at the Castelli Gallery. He had suggested to Warhol that he paint something 'pastoral like cows'. Just as the silver clouds evoked the skies and light airiness, so the *Cow Wallpaper* evoked a down-to-earth stolidity. Warhol was to use it as an overall background for his paintings to hang on in his 1971 retrospective at the Whitney Museum of American Art, New York. For his exhibition of *Mao* paintings at the Musée Galliera, Paris in 1974 Warhol used a wallpaper based on the same images of Chairman Mao.

In 1983 Bruno Bischofberger commissioned Warhol to make a series *Paintings for Children* for his gallery in Zurich. Warhol made a large number of paintings based on the images of vintage, wind-up, mechanical toys from his own collection [50, 99]. When installed in the gallery in Zurich Warhol had them hung low, at a child's eye level, and on *Fish Wallpaper*, which he had designed.

44 | COW WALLPAPER 1966
Screenprint on wallpaper
The Andy Warhol Museum, Pittsburgh, Founding Collection,
Contribution The Andy Warhol Foundation for the Visual Arts, Inc.

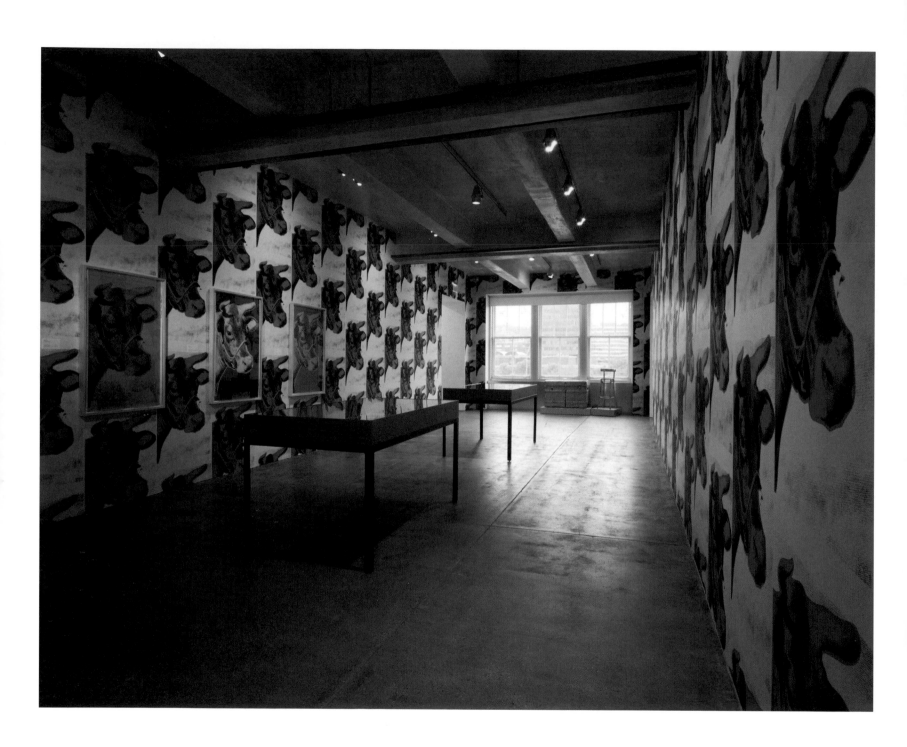

**45 | COW SCREENPRINTS AND COW WALLPAPER
INSTALLATION AT THE ANDY WARHOL MUSEUM,**

The Andy Warhol Museum, Pittsburgh, Founding Collection,
Contribution The Andy Warhol Foundation for the
Visual Arts, Inc.

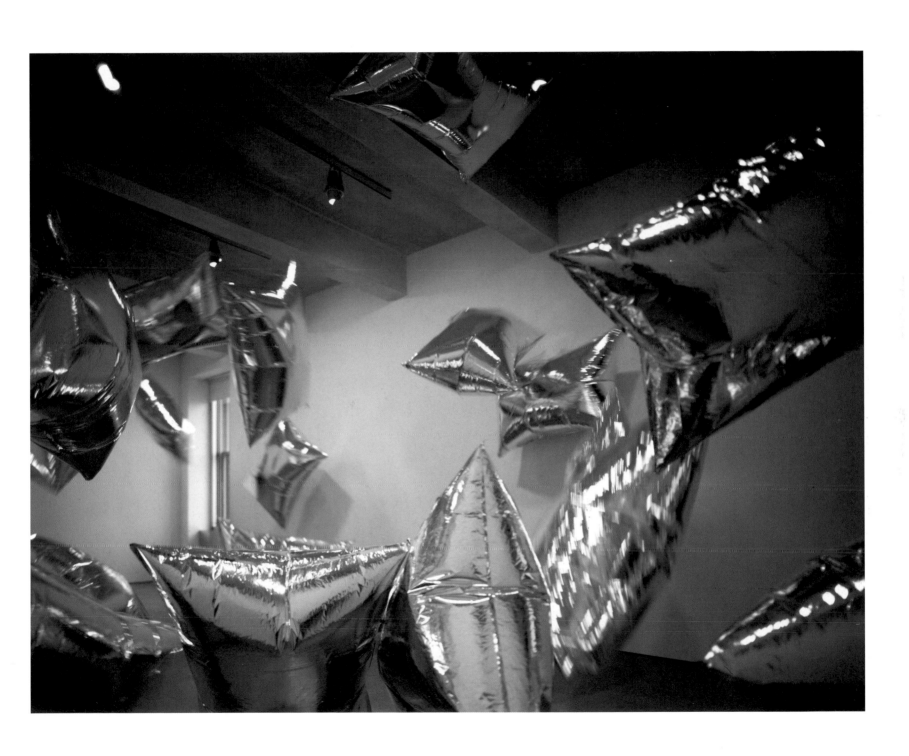

**46 | SILVER CLOUDS INSTALLATION
AT THE ANDY WARHOL MUSEUM**

The Andy Warhol Museum, Pittsburgh, Founding Collection,
Contribution The Andy Warhol Foundation for the
Visual Arts, Inc.

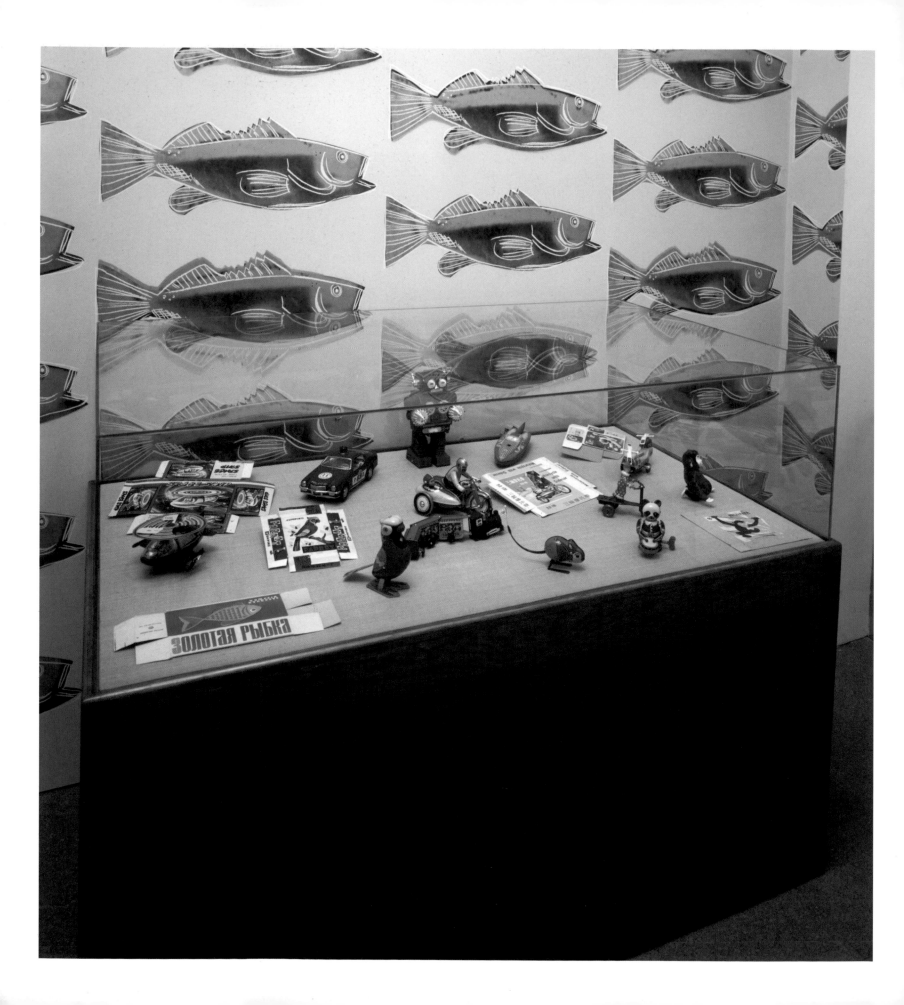

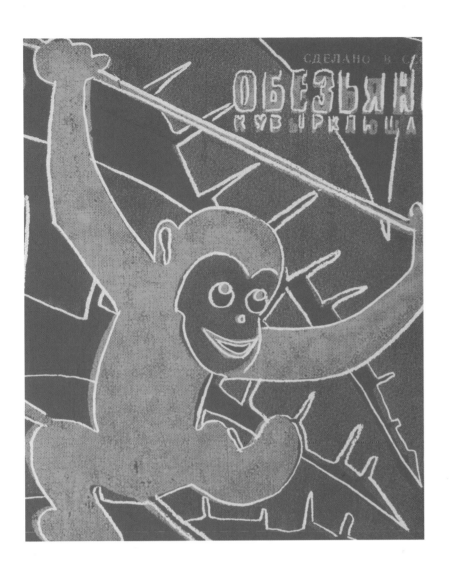

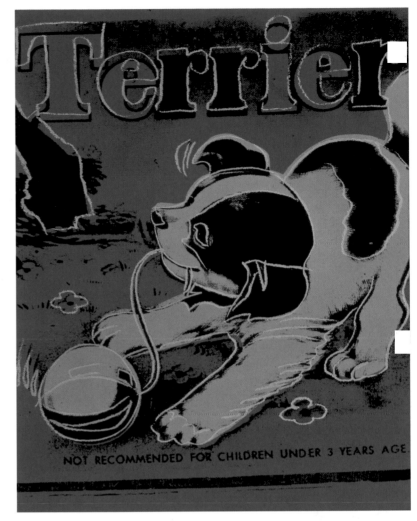

**47 | FISH WALLPAPER INSTALLATION
AT THE ANDY WARHOL MUSEUM** 1998

The Andy Warhol Museum, Pittsburgh, Founding Collection,
Contribution The Andy Warhol Foundation for the
Visual Arts, Inc.

48 | MONKEY 1983

Acrylic and silkscreen ink on linen 25.4 × 20.3cm
The Andy Warhol Museum, Pittsburgh, Founding Collection,
Contribution The Andy Warhol Foundation for the
Visual Arts, Inc.

49 | MECHANICAL TERRIER 1983

Acrylic and silkscreen ink on linen 35.6 × 27.9cm
The Andy Warhol Museum, Pittsburgh, Founding Collection,
Contribution The Andy Warhol Foundation for the
Visual Arts, Inc.

50 | FIPS 1983

Acrylic and silkscreen on canvas 20.3 × 25.4cm
Collection Bruno Bischofberger, Zurich

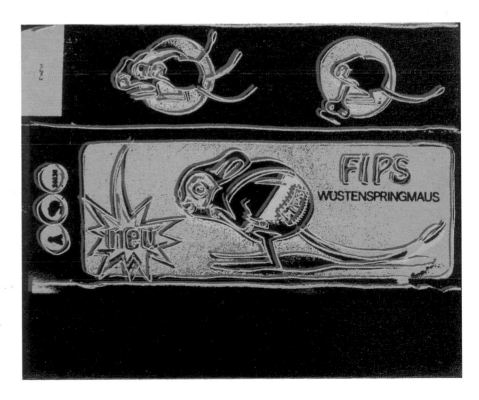

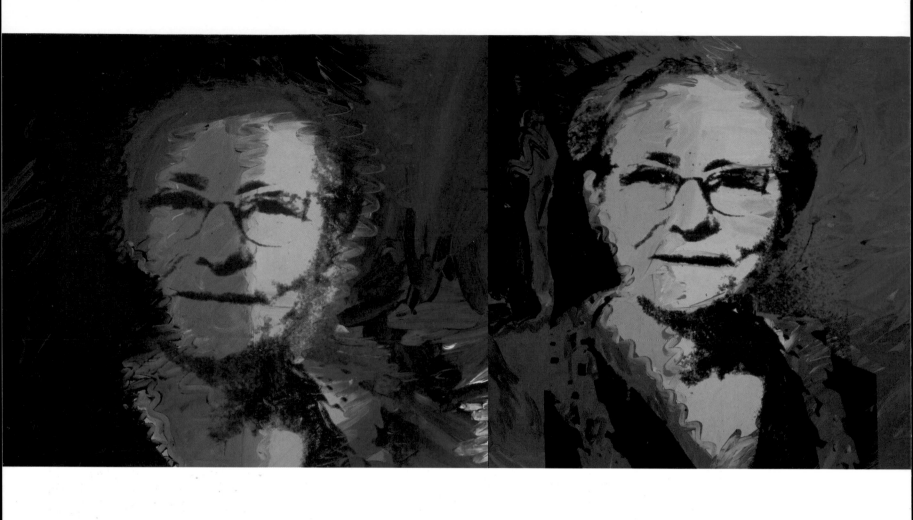

52 | JULIA WARHOLA 1974

Acrylic and silkscreen ink on linen
Two parts, each 101.6 × 101.6cm
The Andy Warhol Museum, Pittsburgh, Founding Collection,
Contribution The Andy Warhol Foundation for the
Visual Arts, Inc.

53 | KEITH HARING AND JUAN DUBOSE 1983

Acrylic and silkscreen ink on linen 101.6 × 101.6cm
The Andy Warhol Museum, Pittsburgh, Founding Collection,
Contribution The Andy Warhol Foundation for the
Visual Arts, Inc.

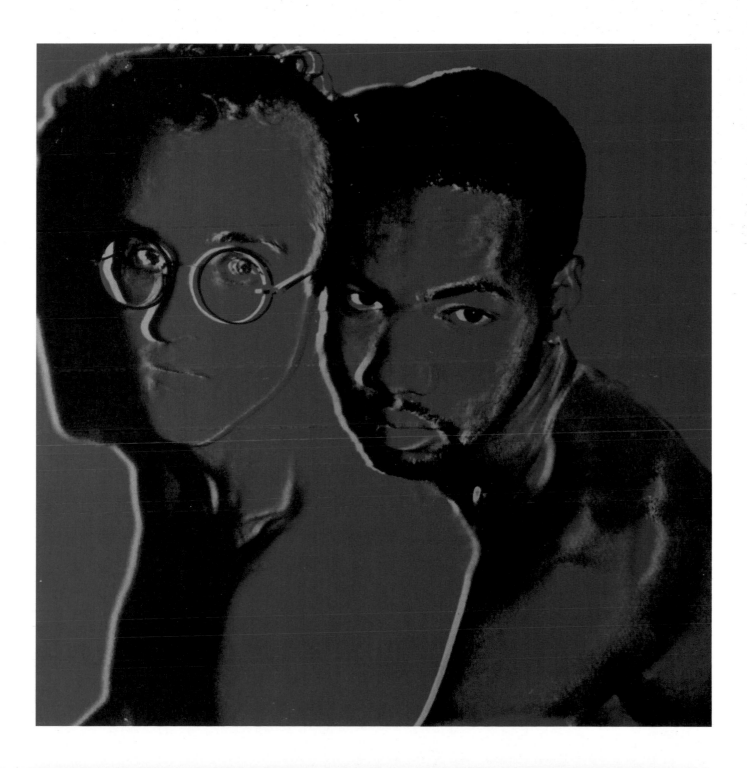

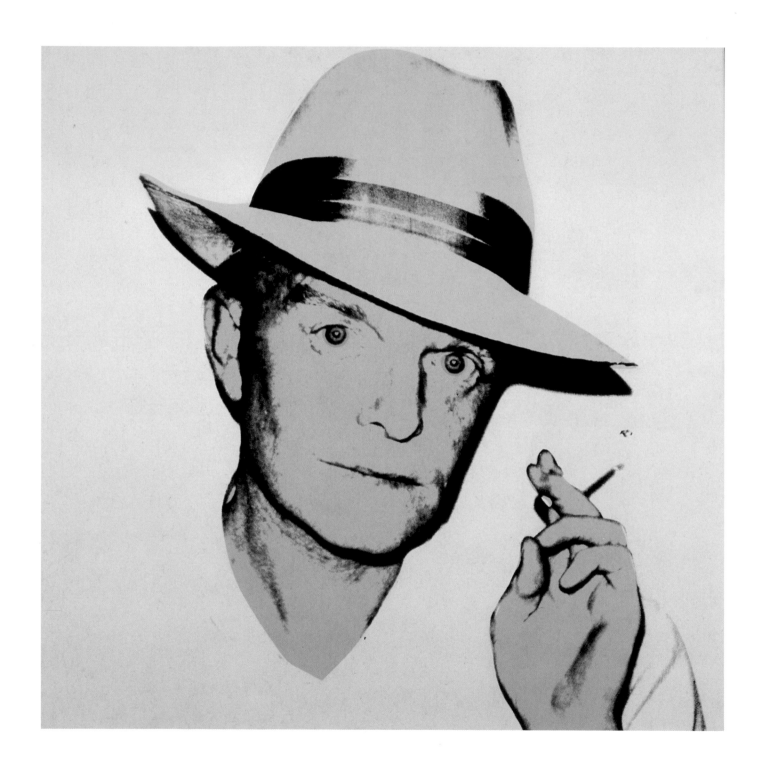

54 | TRUMAN CAPOTE 1979

Acrylic and silkscreen ink on linen 101.6 × 101.6cm
The Andy Warhol Museum, Pittsburgh, Founding Collection,
Contribution Dia Center for the Arts

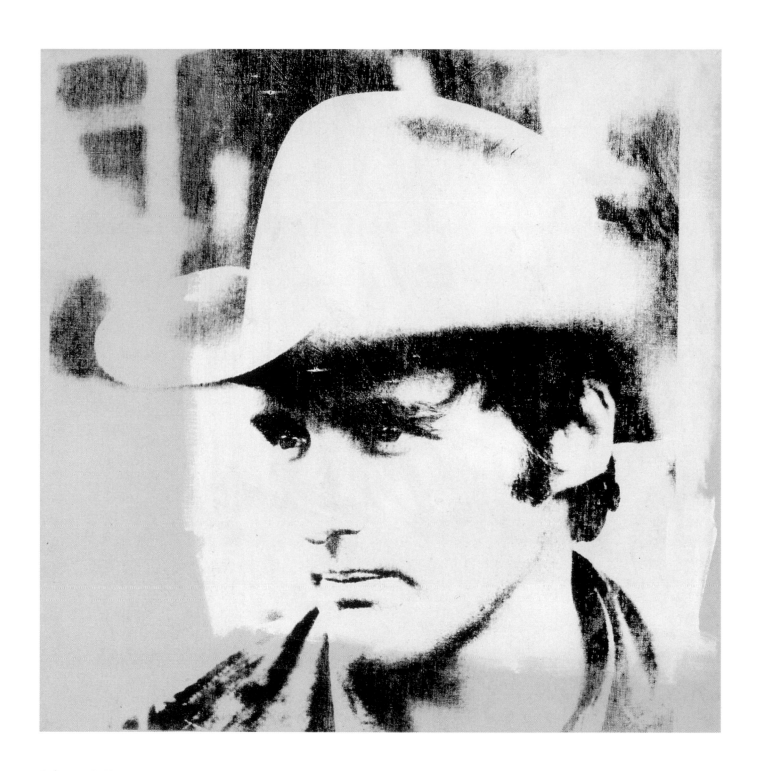

55 | DENNIS HOPPER 1971

Acrylic and silkscreen ink on linen 101.6 × 101.6cm
The Andy Warhol Museum, Pittsburgh, Founding Collection,
Contribution The Andy Warhol Foundation for the
Visual Arts, Inc.

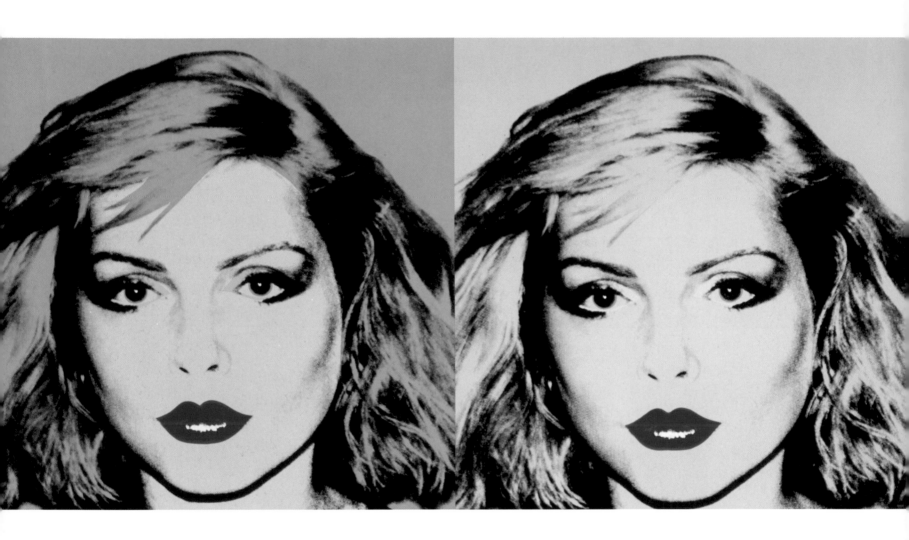

56 | DEBBIE HARRY 1980

Acrylic and silkscreen ink on linen
Two parts, each 106.7 × 106.7cm
The Andy Warhol Museum, Pittsburgh, Founding Collection,
Contribution The Andy Warhol Foundation for the
Visual Arts, Inc.

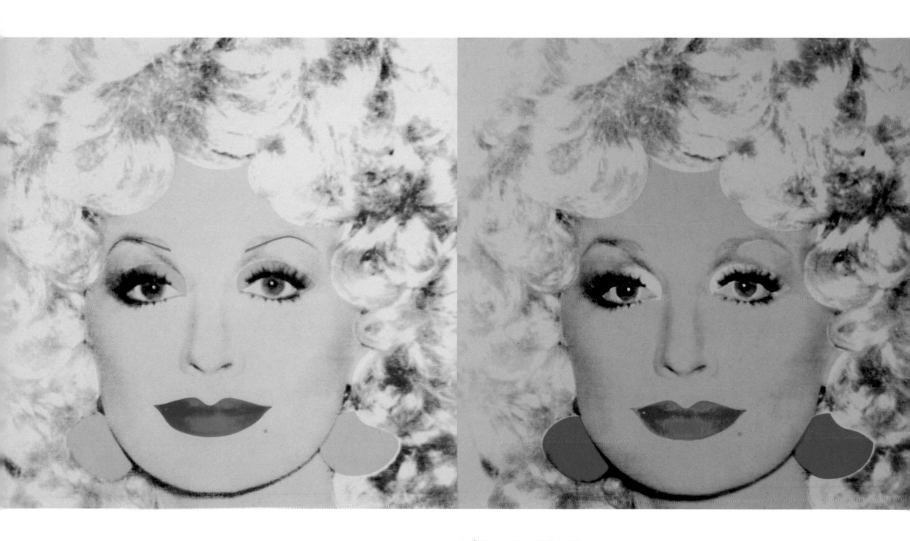

57 | DOLLY PARTON 1985

Acrylic and silkscreen ink on linen
Two parts, each 106 7 × 106.7cm
The Andy Warhol Museum, Pittsburgh, Founding Collection,
Contribution The Andy Warhol Foundation for the
Visual Arts, Inc.

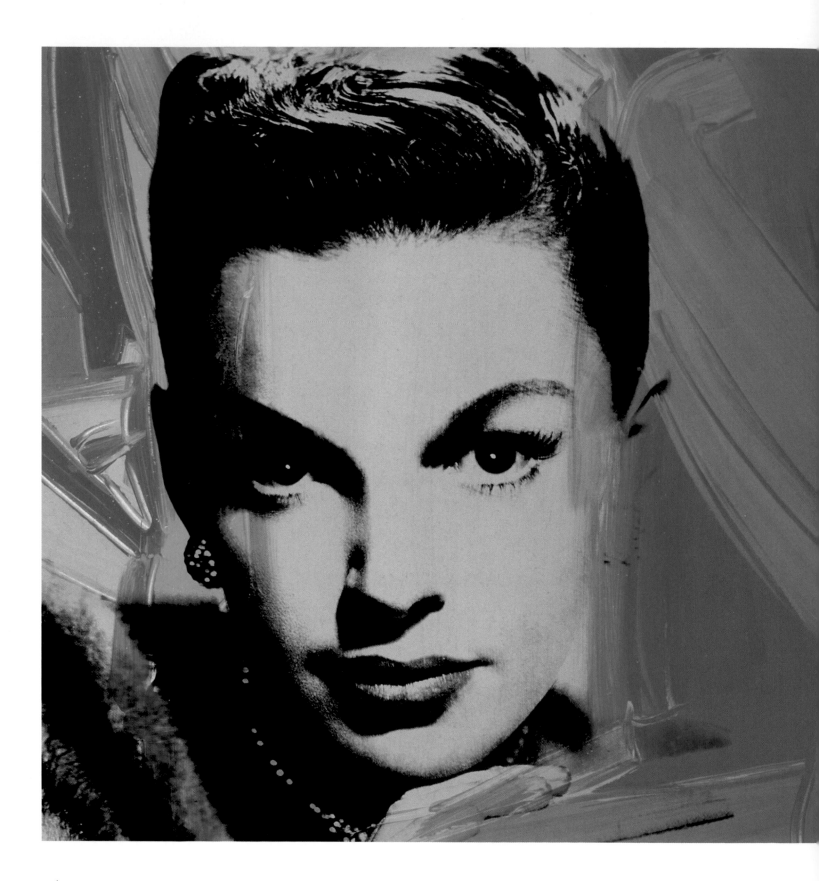

58 | JUDY GARLAND c.1979
Acrylic and silkscreen ink on canvas · two parts, each 101.6 × 101.6cm
The Andy Warhol Museum, Pittsburgh, Founding Collection,
Contribution The Andy Warhol Foundation for the Visual Arts, Inc.

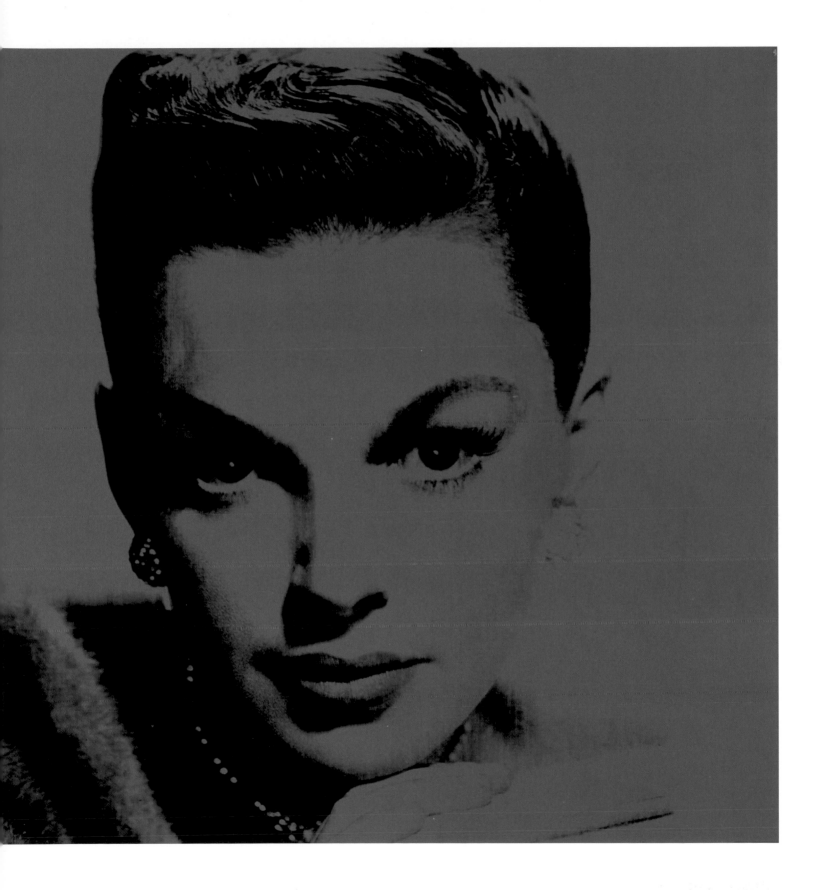

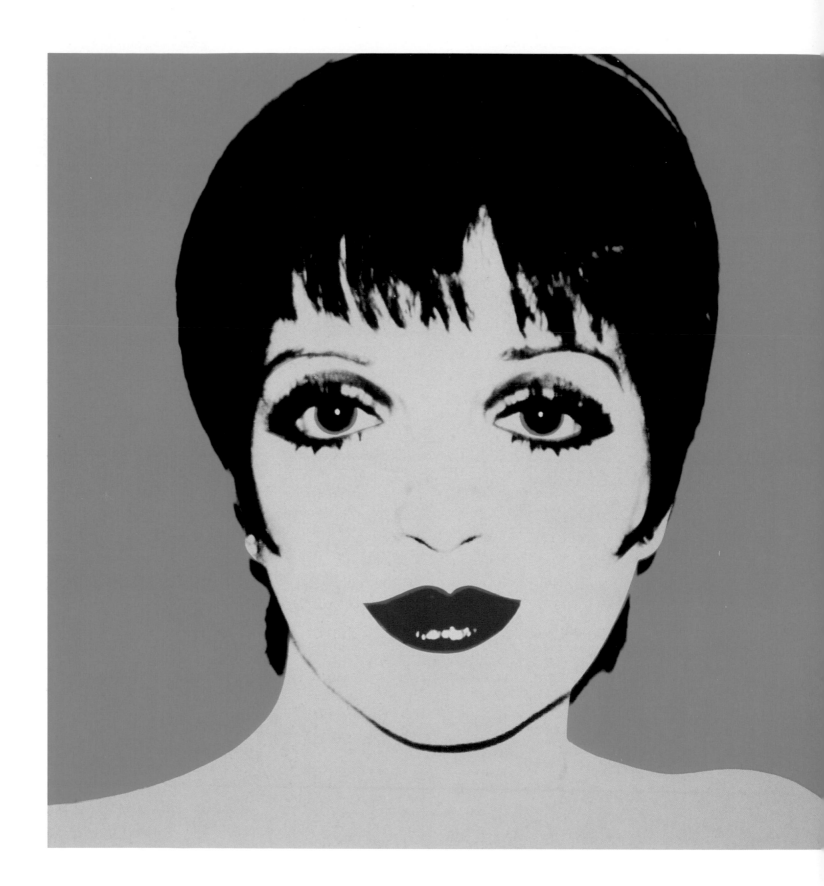

59 | LIZA MINNELLI 1979

Acrylic and silkscreen ink on linen · two parts, each 101.6 × 101.6cm
The Andy Warhol Museum, Pittsburgh, Founding Collection,
Contribution Dia Center for the Arts

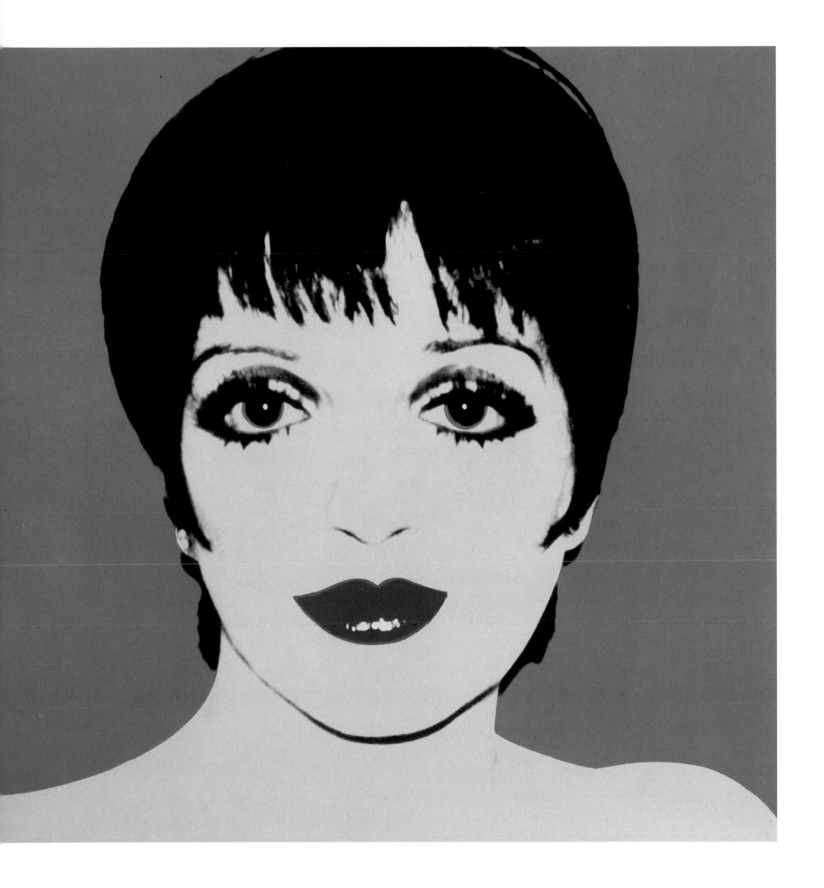

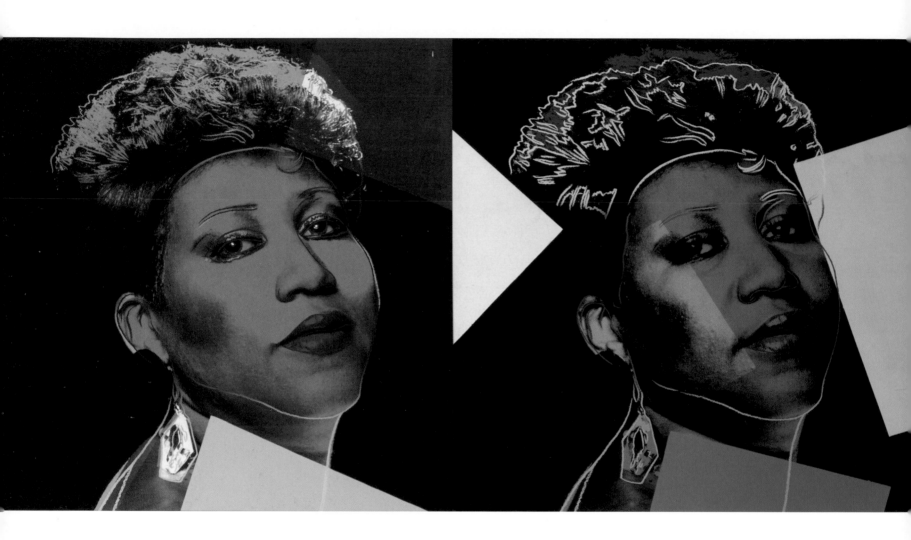

60 | ARETHA FRANKLIN c.1986

Acrylic and silkscreen ink on canvas
Two parts, each 101.6 × 101.6cm
The Andy Warhol Museum, Pittsburgh, Founding Collection,
Contribution The Andy Warhol Foundation for the
Visual Arts, Inc.

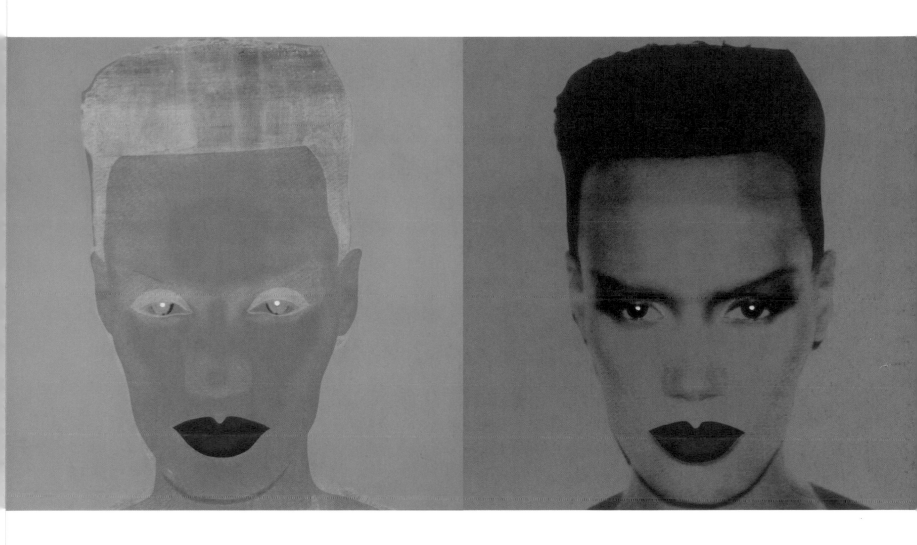

61 | GRACE JONES 1986

Acrylic and silkscreen ink on linen
Two parts, each 101.6 × 101.6cm
The Andy Warhol Museum, Pittsburgh, Founding Collection,
Contribution The Andy Warhol Foundation for the
Visual Arts, Inc.

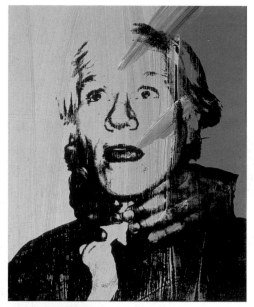
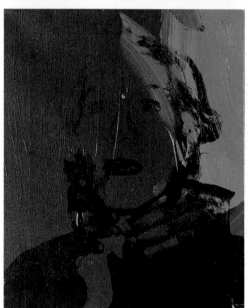
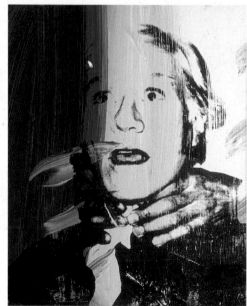
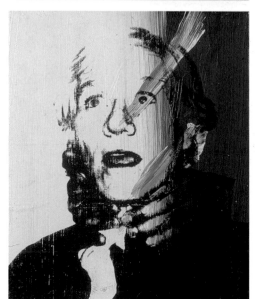
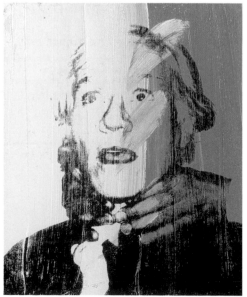

64 | **SELF-PORTRAIT (STRANGULATION)** 1978
Acrylic and silkscreen ink on canvas
Six parts, each 40.6 × 33cm
Scottish National Gallery of Modern Art, Edinburgh,
on loan from a Private Collection

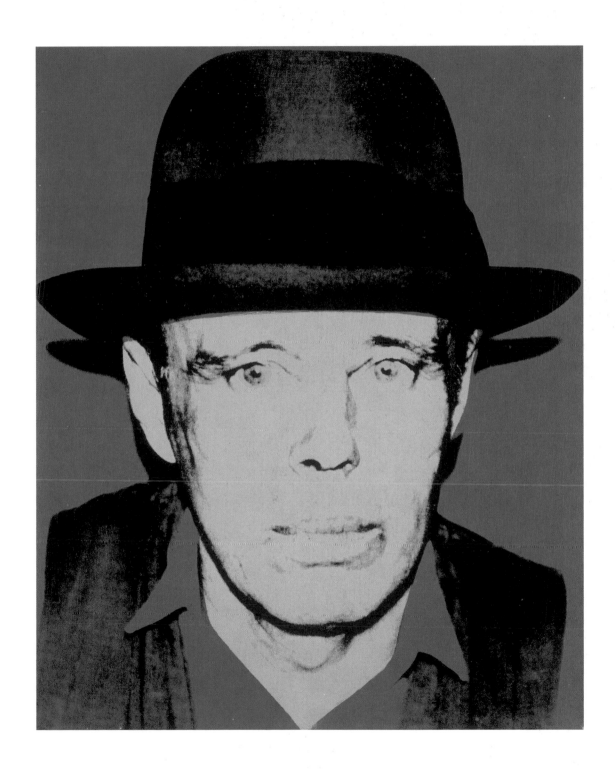

65 | PORTRAIT OF JOSEPH BEUYS 1980

Synthetic polymer paint and silkscreen ink on canvas
50.8 × 40.6cm
Scottish National Gallery of Modern Art, Edinburgh
on loan from a Private Collection

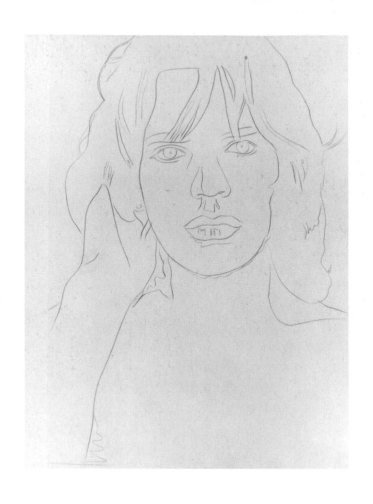

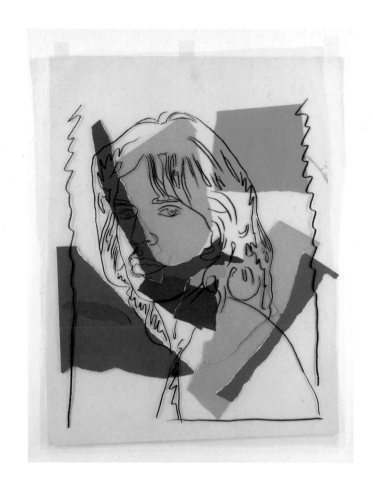

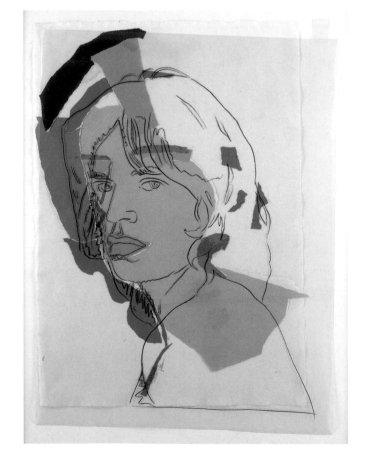

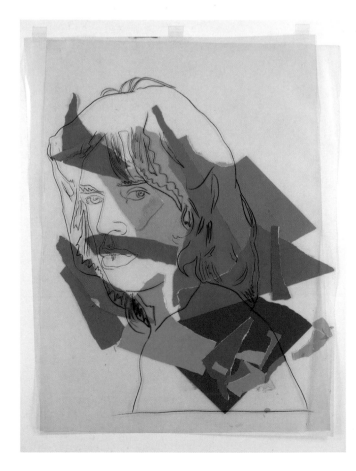

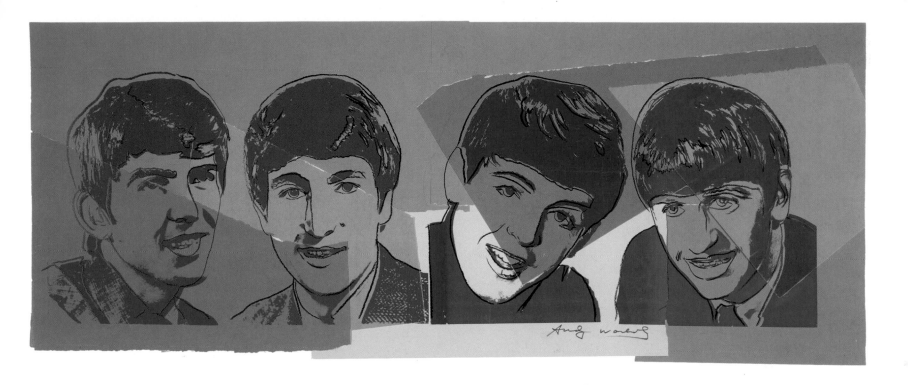

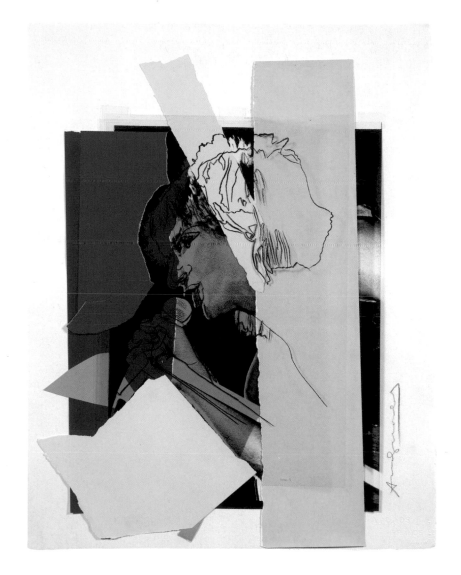

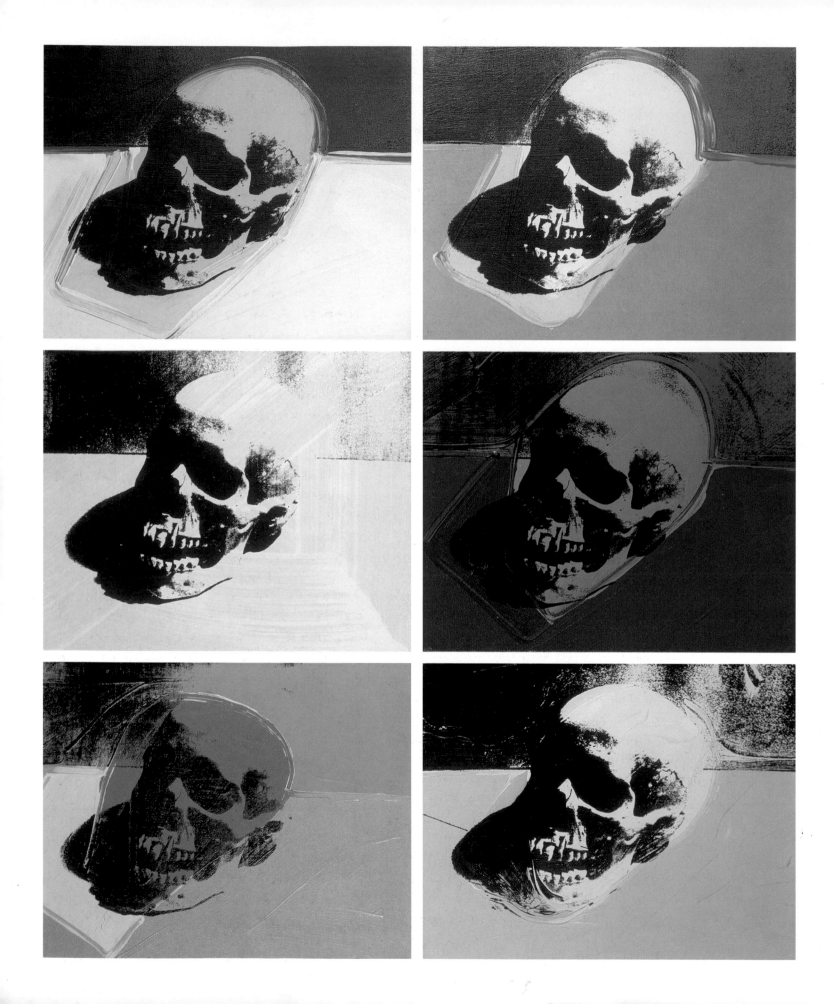

In the last ten years of his life, the twin themes of death and religion became increasingly dominant in Warhol's work, from his *Skull* series of 1976 through to *The Last Supper* paintings of 1986 [**12**]. These last works were shown in Milan just across the Piazza from Santa Maria delle Grazie which houses Leonardo da Vinci's famous mural, *The Last Supper*, which had formed the basis for Warhol's paintings. Within a month Warhol was to die after a seemingly successful gall bladder operation. Warhol had been plagued with gall bladder problems for several years, but because of his fear of hospitals he refused to have it removed, until the pain became so intense that he finally succumbed.

Warhol was a religious man, attending a Catholic church virtually every Sunday throughout his life. The skull paintings of 1976 are not specifically religious in their subject matter, although the related *Self-portrait with Skull* works of 1978 suggest that Warhol was working within the *momento*

War, Death & Religion

mori ('remember you must die') tradition that includes saints contemplating skulls. The skull paintings (which were made in varying sizes) are based on a photograph of an actual skull that Warhol purchased in Paris. The photograph was taken in such a way as to accentuate the shadows not only of the eye sockets and mouth, but also the shadow cast by the skull as a whole. Many observers have noted that this cast shadow has the form of a baby's profile. Whether Warhol chose this particular photograph for this reason, is unknown, but it seems unlikely that his sharp gaze would have missed this feature, which neatly encapsulates birth and death in one image. Perhaps, more importantly, Warhol chose to paint the series of skulls in a variety of bright, cheerful colours – reds, blues, yellows, greens – that are totally at odds with the subject matter and in stark contrast to the traditional browns and ochres of *momento mori* paintings. Death here is not mournful, a subject to be avoided and feared, but something to be accepted as a part of life. Just as he had painted the recently deceased Marilyn Monroe in the bright and gaudy colours of life, so he chose candy colours for the skulls.

While he was still preoccupied with the skull motif, Warhol produced a number of other works in 1978 that dealt with death: the *Oxidation* and the *Shadow* series. The

72 | SKULL 1976
Synthetic polymer paint
and silkscreen ink on canvas
Six parts, each 38.1 × 47.6cm
Scottish National Gallery
of Modern Art, Edinburgh,
on loan from a Private
Collection

Oxidation works were made by covering canvases with copper paint and urinating on them when dry. The acid in the urine reacted with the copper to produce green copper sulphate. Warhol would most certainly have had Jackson Pollock's 'drip' paintings in mind when he made these works, but also, quite possibly, he may have been referring to the alchemical transformation of one substance into another and of the miraculous transfer of Christ's image onto St Veronica's veil. In a number of these paintings Warhol also used images of his friends including the young graffiti artist, Jean-Michel Basquiat, so that their portraits seemed to emerge from the abstract marks left by the urine.

The *Shadow* series like the *Oxidation* series are to all intents and purposes abstract. Warhol had had his studio assistant, Ronnie Catrone, construct an abstract shape out of card and photograph the shadow that it cast. Using silkscreens made from the photograph Warhol made 102 large paintings in various colours. He displayed a number of them edge to edge in the Heiner Friedrich Gallery in New York in 1979, so that the paintings formed an installation in the space. Mysterious and suggestive of an absent and unknowable presence, the paintings possess an undeniably numinous quality (despite Warhol's flip remark that they were only 'disco décor').

Death and religion were central themes in several series of Warhol's paintings in 1981. Guns [**78**], crosses [**11**] and knives all depict the eponymous objects starkly against plain or dark backgrounds. In 1985–6 he embarked on an ambitious group of works called, rather anonymously, *Ads and Illustrations*. Returning to the source of some of his earliest paintings, these works are also based on newspaper adverts and, like the 1960 paintings, they are mainly in black and white. Significantly, they were also created by tracing by hand the original adverts before a screen was made. They, therefore, have the raw power and graphic simplicity one might find in woodcuts. The individual subjects vary, but three overall themes emerge: war, death and religion. The mid-1980s was a time of renewed Cold War tension between the Soviet Union and the United States. President Ronald Reagan had referred to the Soviet Union as the 'Evil Empire' in a speech to the National Association of Evangelicals, and called for a 'Strategic Defence Initiative' or 'Star Wars', (as it was popularly known) to 'defend America from Soviet missiles'. The painting, *Map of Eastern U.S.S.R. Missile Bases* [**81**], refers specifically to this. The diptych, *Paratrooper Boots* [**83**], indicated American readiness to meet

the challenge as does another painting called *Airborne. We Kill for Peace*. The values that America was defending were symbolised in a slightly later work of 1986 entitled *Statue of Liberty* or *Fabis Statue of Liberty* [**82**], which celebrates the centenary of the gift to the American people by France of the famous statue. Significantly, Warhol uses the cover image of a tin of French biscuits to provide him with the image. Death and religion were natural subjects to accompany the renewed fear of nuclear war and are correspondingly well-represented in the *Ad and Illustration* series: *Repent and Sin No More!* [**84**]; *Heaven and Hell are Just One Breath Away!*; *Christ $9.98* [**79**]; *The Mark of The Beast*; *Are you 'Different'?* [**80**]; and *Energy-Power*. Many of these works were painted as diptychs, often in positive and negative, black and white contrasts. The stark alternatives offered to us echo the opposition between the two superpowers and their nuclear arsenals.

In 1986, the last full year of his life, Warhol produced three series of paintings that engaged more openly with war, death and religion. The *Camouflage* series, which

Warhol referred to as his 'war pictures', are obviously indebted to military camouflage patterns, but, by painting them in a range of colours from standard khaki and green to red, pink, orange, yellow and blue, Warhol undermined the purely military aspect of the paintings and broadened it out to encompass the very nature of camouflage itself [**85**]. Camouflage is a natural phenomenon. Birds and animals have feathers and fur that allows them to blend in with and become at one with their surroundings. In this sense it becomes a metaphor for anything that hides itself away, refusing to show its true self. In some of his late self-portraits, Warhol disguises his own image with camouflage patterning. He was notorious throughout his life for hiding his real self away. In some of his *Last Supper* paintings Warhol also used khaki and green camouflage paint to break up the (over-) familiar image of Christ at supper with his disciples and return the images of divinity to its mysterious origins [**12**]. The revealed God of the Bible becomes the hidden God of nature.

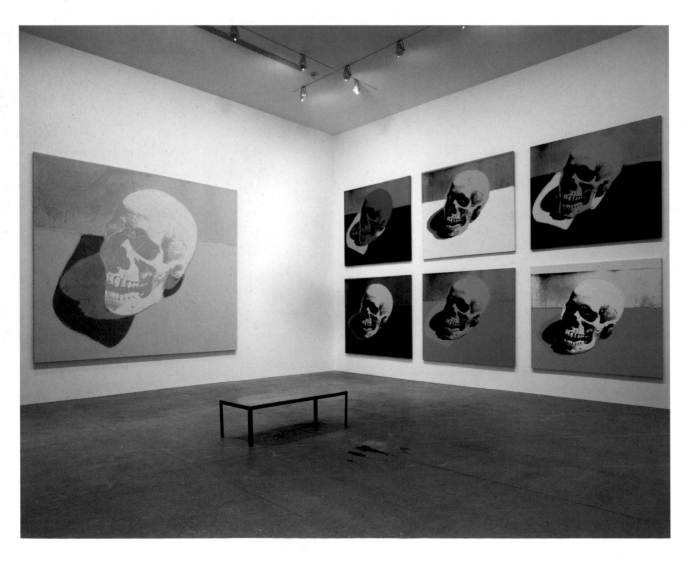

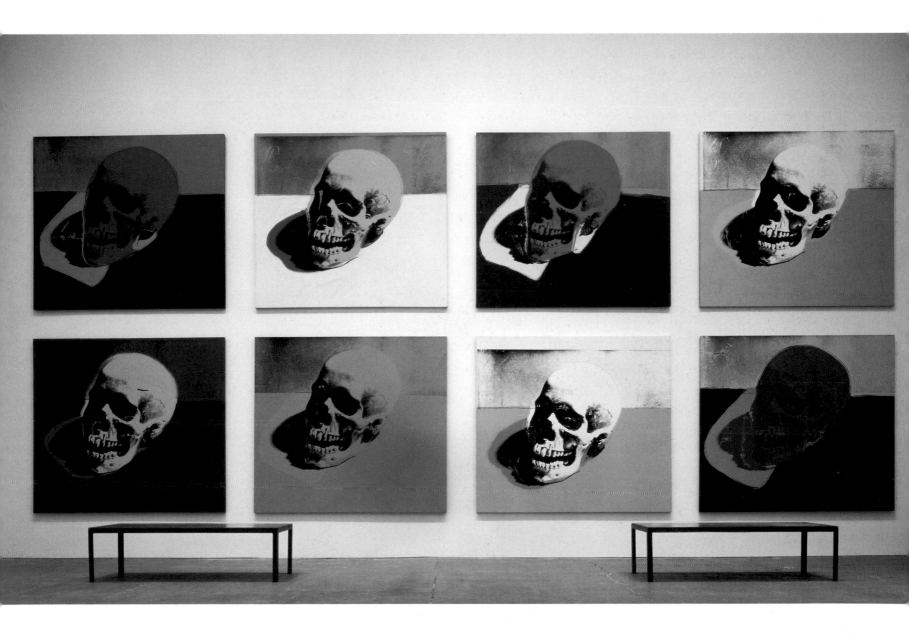

**73 & 74 | SKULL PAINTINGS INSTALLATION
AT THE ANDY WARHOL MUSEUM**

The Andy Warhol Museum, Pittsburgh, Founding
Collection, Contribution The Andy Warhol Foundation
for the Visual Arts, Inc.

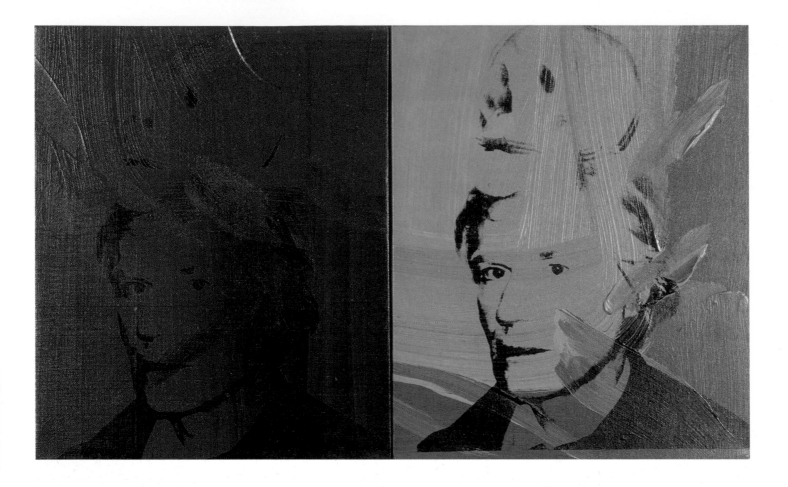

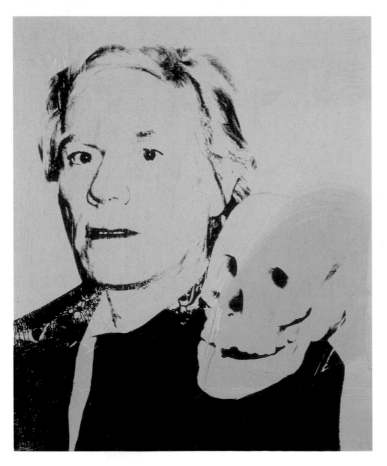

75 | SELF-PORTRAIT WITH SKULL 1978

Synthetic polymer paint and silkscreen ink on canvas
Two parts, each 40.6 × 33cm
Scottish National Gallery of Modern Art, Edinburgh,
on loan from a Private Collection

76 | SELF-PORTRAIT WITH SKULL 1978

Acrylic and silkscreen ink on canvas 40.6 × 33cm
Scottish National Gallery of Modern Art, Edinburgh,
on loan from a Private Collection

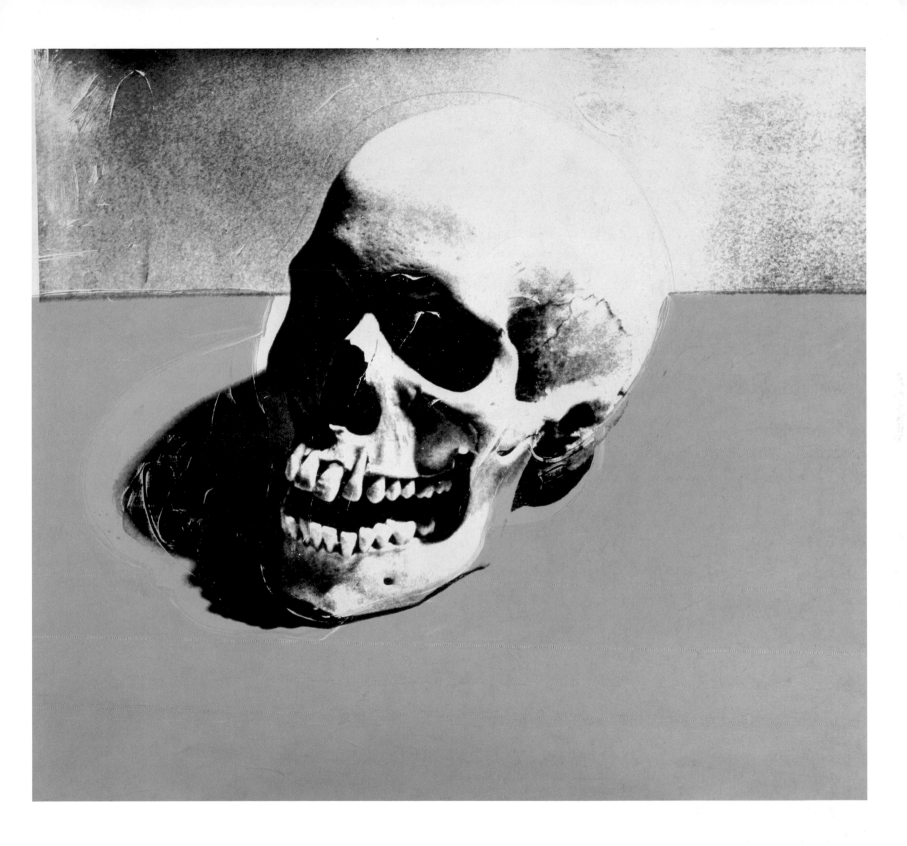

77 | SKULL 1976

Acrylic and silkscreen ink on linen 182.9 × 203.2cm
The Andy Warhol Museum, Pittsburgh, Founding Collection,
Contribution Dia Center for the Arts

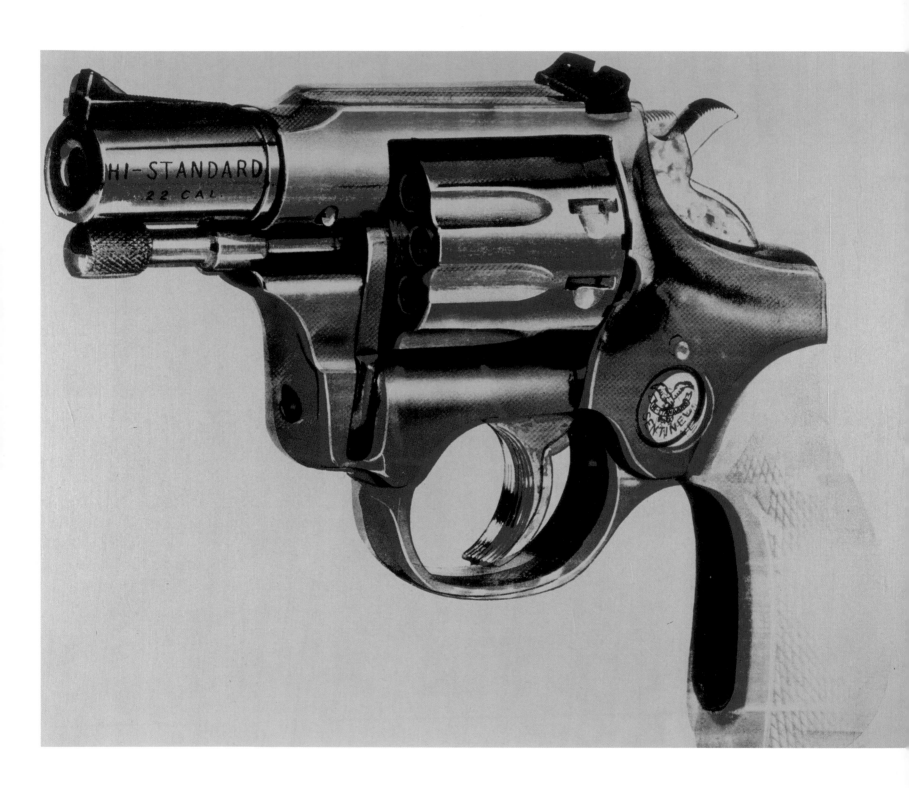

78 | GUN 1981

Synthetic polymer paint and silkscreen ink on canvas
Two parts, each 177.8 × 228.6cm
Scottish National Gallery of Modern Art, Edinburgh,
on loan from a Private Collection

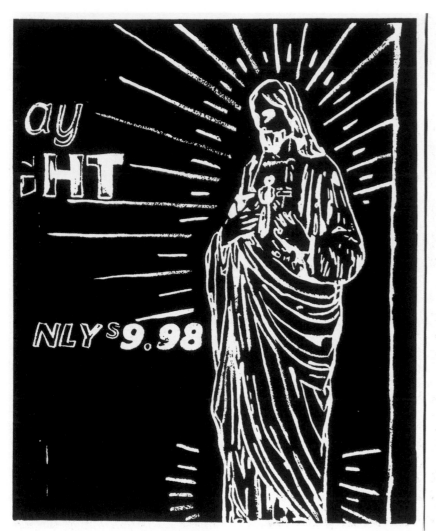
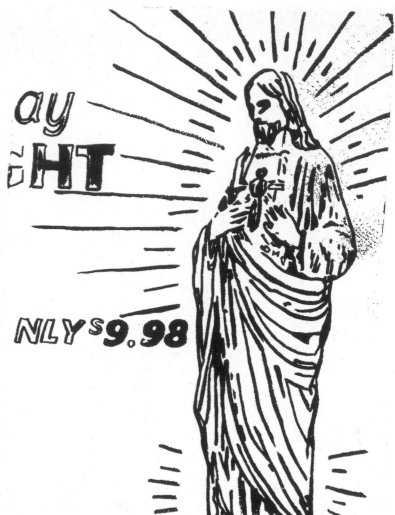

79 | **CHRIST $9.98 (NEGATIVE AND POSITIVE)** 1985–6

Acrylic and silkscreen ink on canvas
Two parts, each 50.8 × 40.6cm
Scottish National Gallery of Modern Art, Edinburgh,
on loan from a Private Collection

80 | ARE YOU 'DIFFERENT'? 1985–6

Acrylic and silkscreen ink on canvas
Two parts, each 66 × 50.8cm
Scottish National Gallery of Modern Art, Edinburgh,
on loan from a Private Collection

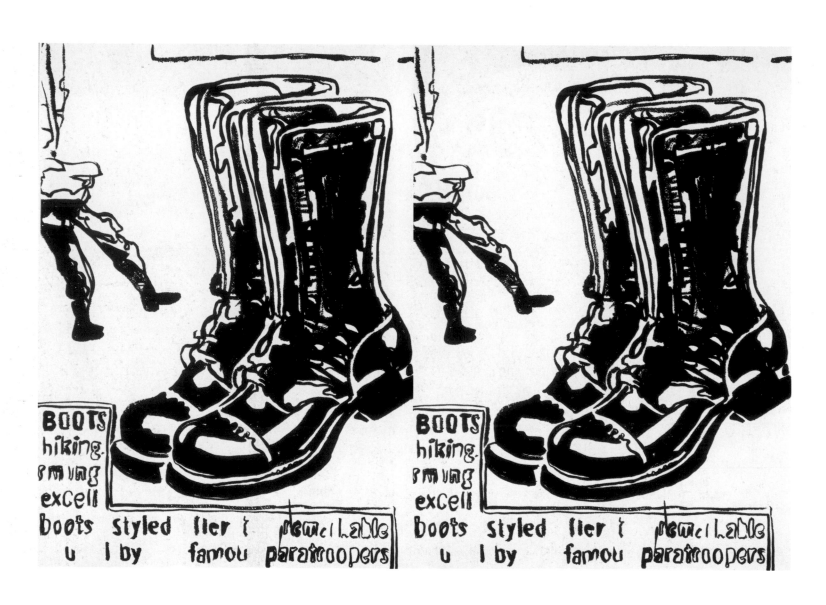

83 | PARATROOPER BOOTS 1985–6

Acrylic and silkscreen ink on canvas
Two parts, each 203.2 × 182.9cm
Scottish National Gallery of Modern Art, Edinburgh,
on loan from a Private Collection

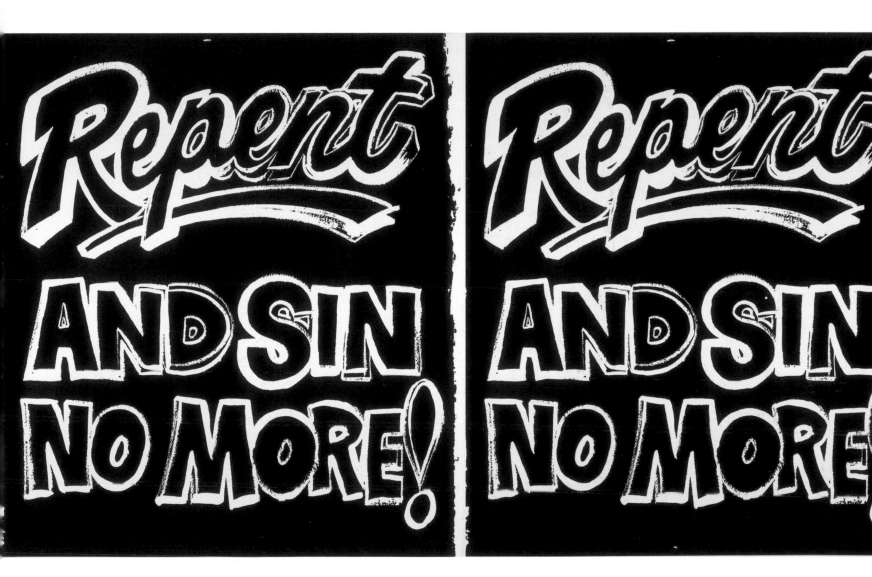

84 | REPENT AND SIN NO MORE! 1985–6

Acrylic and silkscreen ink on canvas
Two parts, each 203.2 × 177.8cm
Scottish National Gallery of Modern Art, Edinburgh,
on loan from a Private Collection

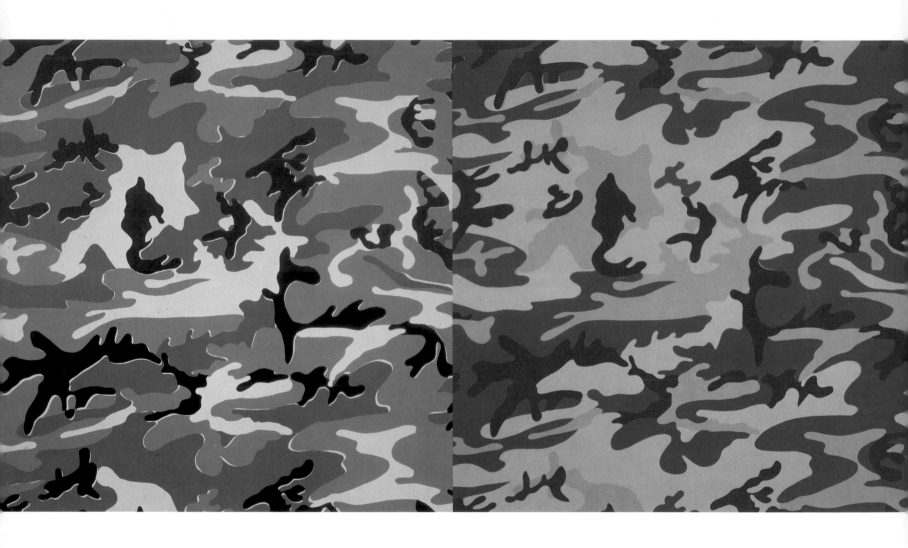

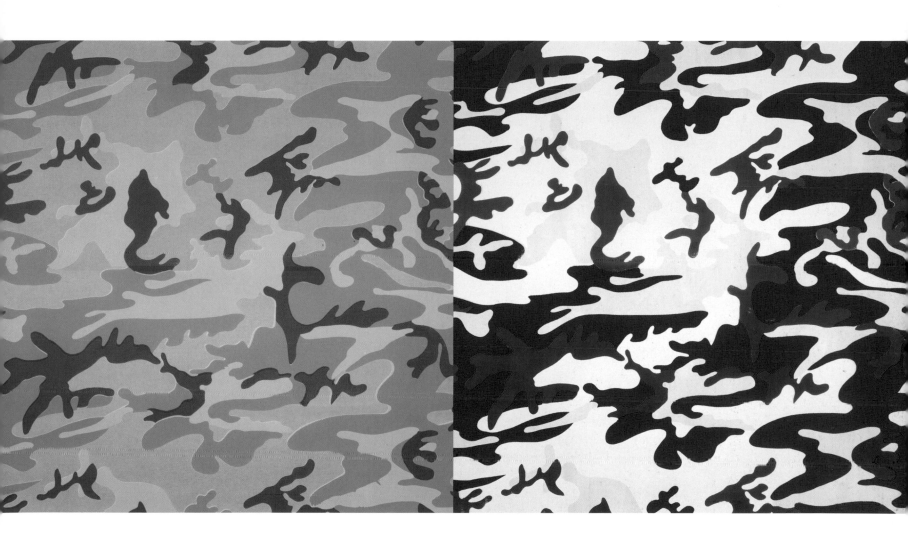

85 | CAMOUFLAGE 1986

Synthetic polymer paint and silkscreen ink on canvas
Four parts, each 182.9 × 182.9cm
Scottish National Gallery of Modern Art, Edinburgh,
on loan from a Private Collection

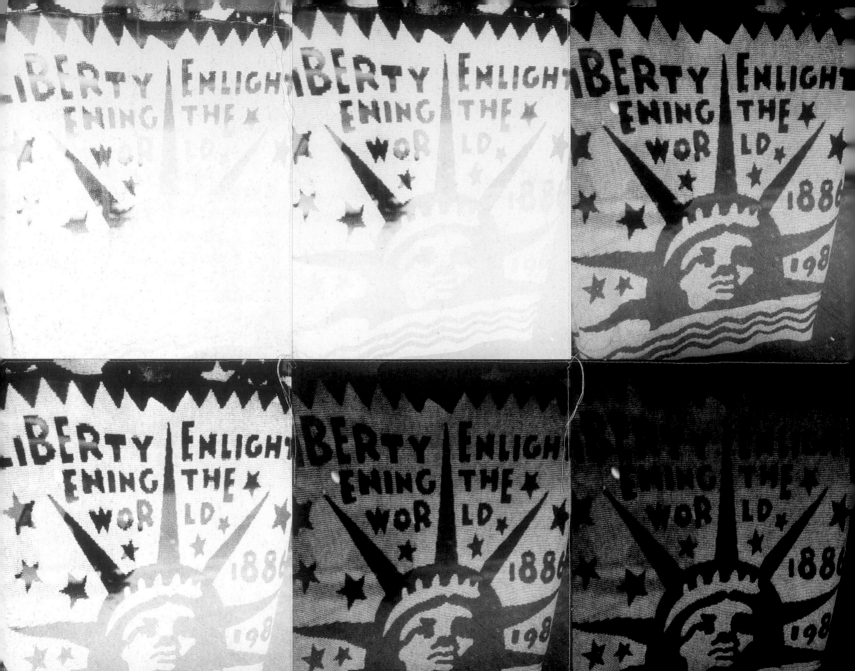

Stitched Photographs

In 1976 Warhol was given a small 33mm camera by Thomas Ammann, a Swiss dealer and friend. Until then, Warhol had carried about with him a Sony tape recorder to document what happened during the day and especially in the evening at parties and dinners. But from now until his death it was his camera that was his constant companion. He used it not only to record the people he met but to capture the things that intrigued him on the streets of New York and especially in the shop windows. Sometimes chosen for their abstract pattern but more often for their extraordinary ordinariness or almost surreal strangeness, these images have something of the street photographs of Eugène Atget and Walker Evans. He also used a camera to take consciously composed photographs of nudes in the studio. In the ten years that he had the camera, Warhol took tens of thousands of black and white photographs, most of which never got beyond the negative or contact sheet stage. Some, however, found their way into his books such as *Exposures*, 1979, and *America*, 1985, and some, a relatively small number, were used by Warhol in 1986 for what became known as his stitched photographs.

Returning to his earlier predilection for repetition, Warhol used multiple (4, 6 or 12) prints of the same photograph that he then had sewn together to form a composite work of art. The thread used was not cut off tidily at the end of a row, but left to hang down and make clear how the work had been made. In the beginning Warhol experimented with collages of different photographs (and different sizes), but this approach evidently did not satisfy him. Perhaps it was too arty and arbitrary. By repeating the same image (occasionally he varied the printing of the photographs to achieve a range of tones from dark to light, as in *Jean-Michel Basquiat* [**89**]), Warhol could extend the abstract design for example in, *Sidewalk* [**94**] and all the nudes [**91**, **92**], to the whole work and he could emphasise the broader significance of what might seem to be peculiarly singular and oddball. Warhol is suggesting that the world is made up of the strange and the unexpected and it is precisely the strange and the unexpected that provide an insight into the world's true nature. For example, traveling in a New York cab, Warhol noticed a number of hand-written signs informing the passengers, among other things, that, if they had a cough, the cabdriver had cough drops available. In a shop window he noticed a group of dolls dressed up in church vestments. These quirky things are the things that most of us notice at some time or another, but that Warhol habitually noticed and, what is more, photographed. As Warhol's former assistant, Gerard Malanga wrote in the *Village Voice* on seeing the exhibition of stitched photographs in the Robert Miller Gallery in New York in January 1987: 'The sewn or stitched photographs are brilliant because they transcend in the most magical way possible the literal, mundane accuracies they convey.'

86 | STATUE OF LIBERTY GRAPHICS 1976–86
Gelatin silver prints sewn with thread 71.1 × 83.8cm
Scottish National Gallery of Modern Art, Edinburgh,
on loan from a Private Collection

87 | APOLLONIA VON RAVENSTEIN 1976–86

Gelatin silver prints sewn with thread 54.6 × 69.2cm
The Andy Warhol Museum, Pittsburgh, Founding Collection,
Contribution The Andy Warhol Foundation for the
Visual Arts, Inc.

88 | UNIDENTIFIED FEMALE 1976–86

Gelatin silver prints sewn with thread 69.9 × 54.3cm
The Andy Warhol Museum, Pittsburgh, Founding Collection,
Contribution The Andy Warhol Foundation for the
Visual Arts, Inc.

89 | JEAN-MICHEL BASQUIAT 1976–86

Gelatin silver prints sewn with thread 69.9 × 80.6cm
The Andy Warhol Museum, Pittsburgh, Founding Collection,
Contribution The Andy Warhol Foundation for the
Visual Arts, Inc.

90 | GRACE BEING PAINTED 1976–86

Gelatin silver prints sewn with thread 71.1 × 83.8cm
Scottish National Gallery of Modern Art, Edinburgh,
on loan from a Private Collection

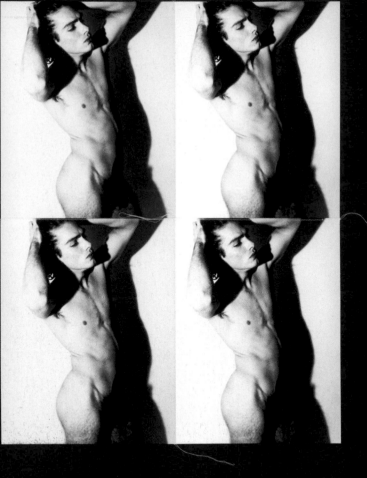

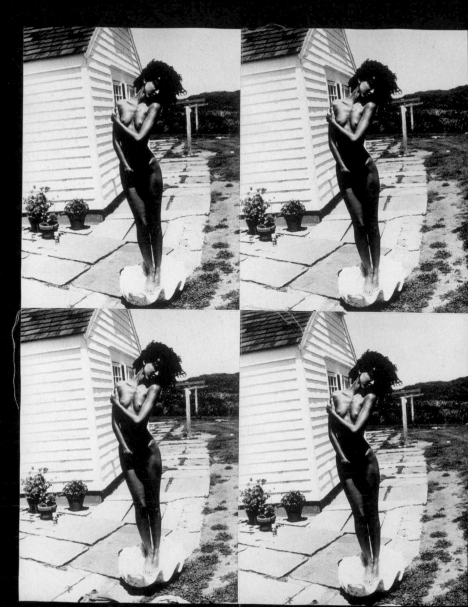

left to right

91 | MALE NUDE STANDING 1976–86

Gelatin silver prints sewn with thread 69.2 × 54cm
The Andy Warhol Museum, Pittsburgh, Founding Collection,
Contribution The Andy Warhol Foundation for the
Visual Arts, Inc.

92 | NUDE WOMAN STANDING IN SHELL 1976–86

Gelatin silver prints sewn with thread 71.1 × 55.9cm
Scottish National Gallery of Modern Art, Edinburgh,
on loan from a Private Collection

93 | TRASH 1976–86

Gelatin silver prints sewn with thread 54.3 × 69.9cm
The Andy Warhol Museum, Pittsburgh, Founding Collection,
Contribution The Andy Warhol Foundation for the
Visual Arts, Inc.

94 | SIDEWALK 1976–86

Gelatin silver prints sewn with thread 54 × 69.9cm
The Andy Warhol Museum, Pittsburgh, Founding Collection,
Contribution The Andy Warhol Foundation for the
Visual Arts, Inc.

Time Capsules

Warhol was obsessive about time and did everything in his power to arrest it, or, at least, to alleviate the effects of its passing. In his paintings he could repeat the same image over and over again; in his photographs he could literally stop time and capture it as an image; in his films he could slow it down and / or film the same person (*Sleep*) or object (The Empire State Building in *Empire*) over many hours so that time *seemed* to stretch out into infinity; in his audio tapes he could record for posterity the conversations and interviews with the people he met. Warhol was also ravenous for experience, cramming as much activity into his days and nights as he possibly could. He was a compulsive shopper and filled his home to bursting with the haul from his almost daily forays. And he threw nothing out.

It was this hoarding instinct that led to the creation of the *Time Capsules* in 1974. This was the year in which Warhol moved his studio and business operations from 33 Union Square to 860 Broadway. Since Warhol threw virtually nothing away, from correspondence, magazines, books, cab slips, photographs and presents to business files, there was a huge amount to move from one site to the other. Everything was placed into cardboard boxes for the move. Warhol thought that these were an excellent way of storing his past archives and that similar boxes could be used as an ongoing storage system. In his book *The Philosophy of Andy Warhol: From A to B and Back Again* he explained how he used the cardboard boxes: 'What you should do is get a box for a month, and drop everything in it and at the end of the month lock it up. Then date it and send it over to Jersey...I just drop everything into the same-size brown cardboard boxes that have a colour patch on the side for the month of the year. I really hate nostalgia, though, so deep down I hope they all get lost and I never have to look at them again. That's another conflict. I want to throw things right out the window as they're handed to me, but instead I say thank you and drop them into the box-of-the-month. But my other outlook is that I really do want to save things, so they can be used again someday.'

Warhol later saw the *Time Capsules* as a work of art, something that he might even consider selling. They were, after all, a form of self-portrait. The 612 *Time Capsules* that are now kept in The Andy Warhol Museum are not only a wonderful archival source for studying Warhol's life and work, but a conceptual artwork and a bulwark that the artist built-up against the passage of time and death. The words of T.S. Eliot in *The Wasteland* seem peculiarly apt: 'These fragments I have stored against my ruin.'

95 | TIME CAPSULES (72) DISPLAYED AT
THE ANDY WARHOL MUSEUM, PITTSBURGH,

The Andy Warhol Museum, Pittsburgh, Founding Collection,
Contribution The Andy Warhol Foundation for the
Visual Arts, Inc.

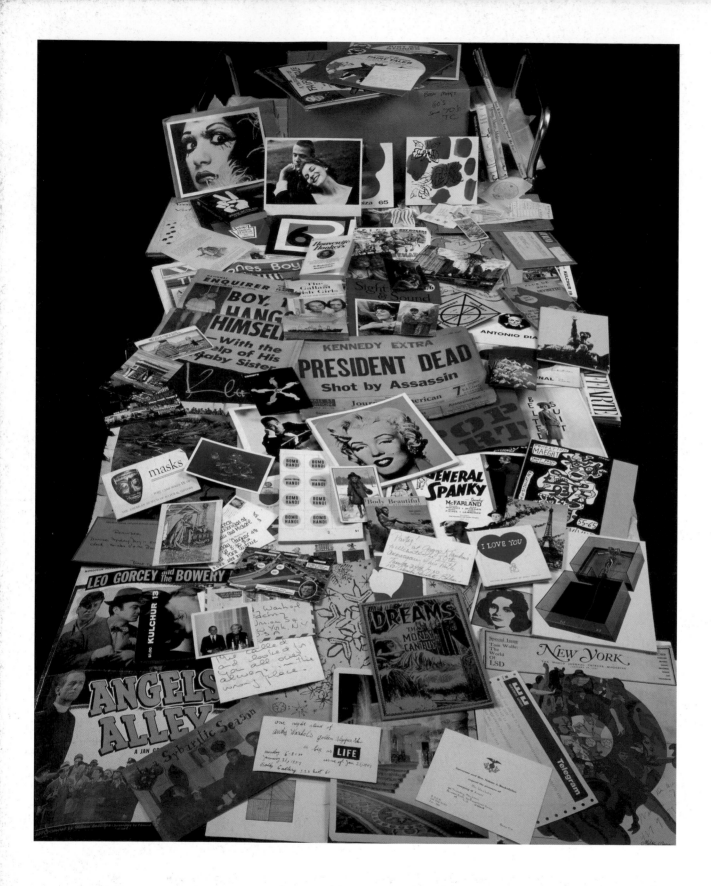

**96 | CONTENTS OF ANDY WARHOL'S
TIME CAPSULE 44,**

The Andy Warhol Museum, Pittsburgh, Founding Collection,
Contribution The Andy Warhol Foundation for the
Visual Arts, Inc.

**97 | TIME CAPSULES (72) DISPLAYED AT
THE ANDY WARHOL MUSEUM, PITTSBURGH,**

The Andy Warhol Museum, Pittsburgh, Founding Collection,
Contribution The Andy Warhol Foundation for the
Visual Arts, Inc.

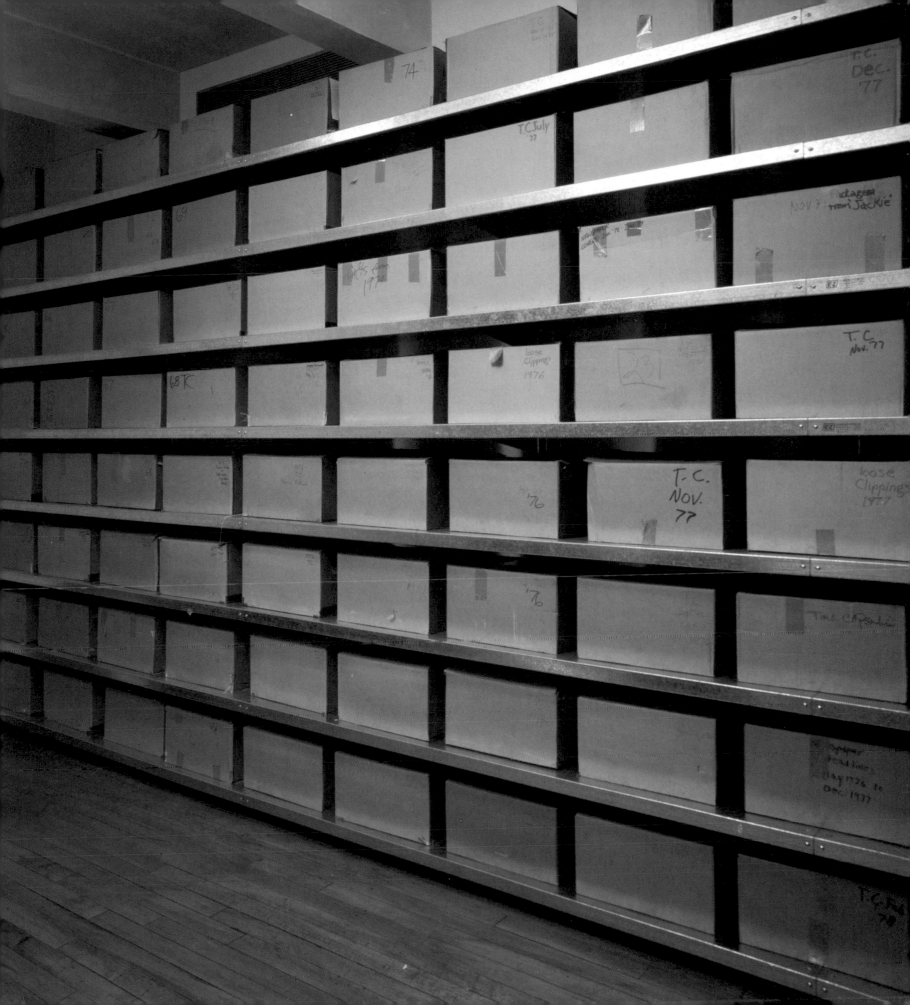

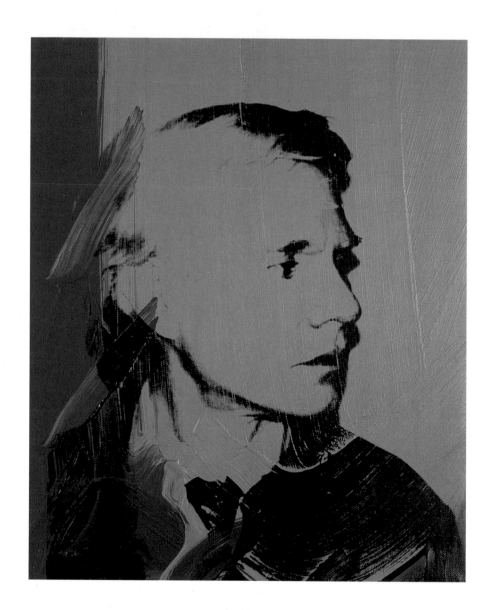

98 | SELF-PORTRAIT 1978

Synthetic polymer paint and silkscreen ink on canvas 40.6 × 33cm
Scottish National Gallery of Modern Art, Edinburgh,
on loan from a Private Collection

Chronology

LAUREN RIGBY

1928

Andrew Warhola is born on 6 August in Pittsburgh, Pennsylvania. His parents, Andrej and Julia Warhola, emigrated to the United States in 1912 from a village now on the Slovakian border with Ukraine. He has two elder brothers, Paul (b.1922) and John (b.1925). The Warholas are deeply involved with the local Ruthenian religious community which has a strong influence on Warhol's childhood.

1934

Enrols at Holmes Elementary School. His mother gives him a film projector, which allows him to project cartoons onto the walls at home and he begins to draw and paint.

1936

Diagnosed with St Vitus' Dance, a nervous disorder. As a result he spends several weeks in bed, colouring and cutting out designs with paper, and reading comic books and magazines. He begins to collect photographs and autographs of film stars.

1937

Attends a free art course on Saturday mornings at the Carnegie Institute of Technology until 1941.

1941

Attends Schenley High School until 1945. Has his picture taken in a photo booth for the first time.

1942

Andrej Warhola dies after a period of prolonged illness.

1945

Enrols at the Carnegie Institute of Technology (now Carnegie Mellon University) and majors in pictorial design. He meets fellow student Philip Pearlstein. Teaches art part-time and, during his summer vacations, works as a window-dresser at the Joseph Horne department store in Pittsburgh.

1948

Works as a picture editor for the student magazine. Experiments with a transfer printing process known as the 'blotted-line' technique. This becomes a typical feature of his commercial graphics in the 50s.

1949

Graduates from Carnegie Institute of Technology with a Bachelor of Fine Arts and moves to New York with Philip Pearlstein. He is given his first commission as a commercial artist for *Glamour* magazine to illustrate the article 'Success is a Job in New York'. Other commissions follow for *Vogue, Seventeen, The New Yorker* and *Harper's Bazaar*. He becomes infatuated with Truman Capote after seeing his photograph on the book jacket of *Other Voices, Other Rooms*. He begins to use the name Andy Warhol.

1950

Julia Warhola moves to New York to live with her son and remains there until shortly before her death in 1972. Warhol admires his mother's 'childlike' handwriting and often asks her to write the text for his graphic works, including the signature.

1952

First solo exhibition *Fifteen Drawings Based on the Writings of Truman Capote* held at the Hugo Gallery, New York.

1953

Publishes a series of promotional books with 'Corkie' (Ralph Thomas Ward) to send to art directors and potential clients. Starts his first paintings.

1955

Warhol's designs for the shoe manufacturer I. Miller are published weekly in the *New York Times,* prompting him to publish *A la Recherche du Shoe Perdu.*

1957

Establishes 'Andy Warhol Enterprises Inc.' for his commercial work. By this time, Warhol has become one of the most successful graphic artists in the United States. Dissatisfied with the shape of his nose, he undergoes corrective surgery.

1960

Produces his first paintings featuring comic-strip motifs including Dick Tracy, Batman, Popeye, and Superman.

1961

Views works by Roy Lichtenstein at the Leo Castelli Gallery based on comic strips. Invites Ivan Karp, Castelli's colleague, to see his own comic-strip paintings.

1962

Solo exhibition of thirty-two *Campbell's Soup Cans* at the Ferus Gallery in Los Angeles. Produces his first works in the 'Death and Disaster' series, Coca-Cola bottles, and

portraits of Marilyn Monroe, Elvis Presley, and Elizabeth Taylor.

1963

Makes his first film, *Sleep*. Begins a series of portraits of Jacqueline Kennedy after President John F. Kennedy is assassinated on 22 November. Gerard Malanga becomes Warhol's studio assistant until 1970. Warhol rents a studio in a former fire station on East 87th Street in June and then moves to a loft on East 47th Street in November which becomes known as the The Factory.

1964

The first *Screen Tests* are filmed. Warhol acquires a tape recorder which he carries around constantly to document interviews and conversations. Shows *Brillo Boxes* at the Stable Gallery in New York, and an exhibition of 'Death and Disaster' paintings opens at Galerie Ileana Sonnabend in Paris to great critical acclaim. Creates *Flowers* silkscreens, based on an image by photographer Patricia Caulfield, which are shown in Warhol's first exhibition at the Leo Castelli Gallery in New York.

1965

Edie Sedgwick and the band, The Velvet Underground begin to frequent the The Factory and appear in Warhol's films. Retrospective opens at the Institute of Contemporary Art of the University of Pennsylvania, Philadelphia.

1966

Produces multimedia performances entitled *The Exploding Plastic Inevitable* featuring Velvet Underground and the singer, Nico. Exhibits *Silver Clouds* and *Cow Wallpaper* at the Leo Castelli Gallery. Films *Chelsea Girls*, which gains widespread recognition.

1967

Creates series of large-format *Electric Chair* pictures. He produces Velvet Underground's first album and meets Frederick Hughes who later becomes his manager. *Andy Warhol's Index (Book)* and *Screen Tests: A Diary* are published.

1968

First European retrospective at the Moderna Museet in Stockholm which tours to other European venues. Warhol's work exhibited at *documenta 4* in Kassel. On 3 June, Valerie Solanas, founder of SCUM (Society for Cutting Up Men), enters the Factory and shoots Warhol, severely wounding him. Warhol undergoes several hours of surgery and never fully recovers from his injuries. Solanas hands herself into the police.

1969

The first issue of *Interview* magazine is published.

1970

Extensive retrospective opens at the Pasadena Art Museum which travels to numerous venues in Europe and America.

1972

Starts work on the series of *Mao* portraits. Julia Warhola dies aged eighty.

1974

The Factory moves to 860 Broadway.

1975

The Philosophy of Andy Warhol (from A to B and Back Again), written by Warhol in collaboration with Hackett, is published.

1977

Studio 54 opens in New York. Warhol becomes a regular visitor together with Liza Minnelli and Bianca Jagger. He begins work on the series, *Hammer and Sickles*, *Athletes* and *Torsos*.

1978

Produces portraits of Liza Minnelli, Muhammad Ali and Man Ray and creates his *Oxidation* and *Shadow* works.

1979

Meets Joseph Beuys at Beuys's retrospective at the Guggenheim Museum, New York where Warhol takes Polaroid photographs as source material for subsequent portraits of the artist, which he begins in 1980. The Whitney Museum of American Art presents the exhibition *Andy Warhol: Portraits of the 70s*. *Andy Warhol's Exposures*, a book of the artist's photographs, is published.

1980

Andy Warhol's TV is shown on cable television until 1982.

1983

Collaborates with Jean-Michel Basquiat and Francesco Clemente.

1984

Warhol purchases the Edison Building on East 33rd Street to house his studio, office, and the *Interview* magazine offices.

1986

Produces the *Camouflages*, *Lenin* portraits and *The Last Supper* paintings. MTV shows *Andy Warhol's Fifteen Minutes*. The Anthony d'Offay Gallery in London shows the last series of Warhol's *Self-Portraits*.

1987

Andy Warhol dies in New York on 22 February as a result of post-operative complications arising after gall bladder surgery. He is buried in Pittsburgh and a memorial service, held in St Patrick's Cathedral in New York, is attended by over two thousand mourners. The Andy Warhol Foundation for the Visual Arts is founded to manage the artist's estate and to support cultural organisations.

1994

The Andy Warhol Museum opens in Pittsburgh.

Notes & References

1. Warhol and Hackett 1980, pp.251–2.

2. Goldsmith 2004, p.18.

3. Warhol 1975, p.100.

4. Sontag 1994, pp.275–92.

5. Sontag 1994, p.289.

6. Sontag 1994, p.292.

7. Warhol and Hackett 1980, pp.6–7.

8. Goldsmith 2004, p.19.

9. Warhol and Hackett 1980 p.17.

10. Bockris 1989, p.198.

11. Goldsmith 2004, p.19.

12. Frei and Printz 2002, p.342.

13. John Cale in *The Guardian*, 12 February 2002.

14. Warhol 1975, p.95.

15. Warhol also used the word in the form of books (for example, *A: A Novel*, 1968) and, through his managing of the rock band, The Velvet Underground, music.

16. Warhol and Hackett 1980, p.135.

17. Garrels 1989, pp.93–114.